BRYAN HITCH'S ULTIMATE
COMICSSTUDIO

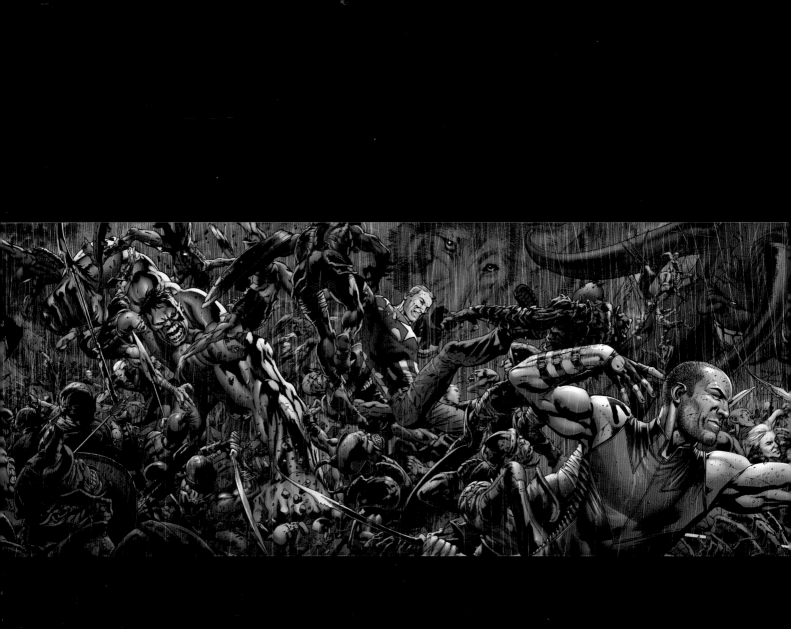

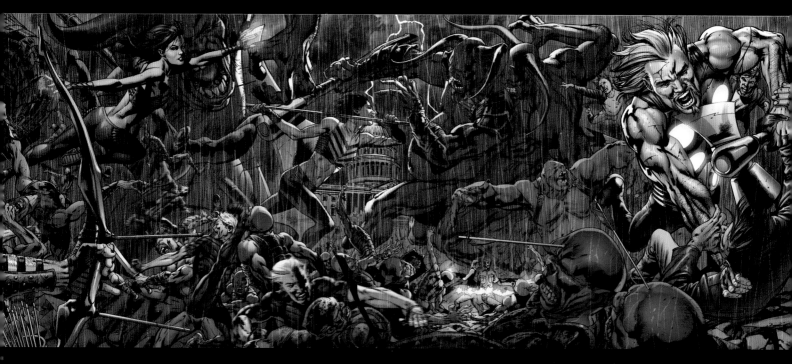

BRYAN HITCH'S ULTIMATE
COMICSSTUDIO

IMPACT

A DAVID & CHARLES BOOK

David & Charles is an F+W Media Inc. company
4700 East Galbraith Road
Cincinnati, OH 45236

First published in 2010

A catalogue record for this book is available from the British Library.

ISBN-13: 978-1-6006-1326-5 hardback
ISBN-10: 1-60061-326-8 hardback

ISBN-13: 978-1-6006-1327-2 paperback
ISBN-10: 1-60061-327-6 paperback

Printed in China by RR Donnelley
for David & Charles
Brunel House, Newton Abbot, Devon

Senior Commissioning Editor: Freya Dangerfield
Project Editor: Emily Pitcher
Editor: Verity Muir
Designer: Sarah Underhill
Design Consultant: Prudence Rogers
Senior Designer: Jodie Lystor
Production Controller: Kelly Smith
Pre Press: Natasha Jorden

David & Charles publish high quality books on a wide
range of subjects.
For more great book ideas visit: www.rubooks.co.uk

Contents

Foreword	6
Introduction	8
Storytelling	15
Composition	31
Drawing	51
Inking & Colour	93
The Business End	107
The Cover	117
Index	128

foreword by Joss Whedon

When I first met Bryan Hitch, I was a little terrified. He was part of the wave of extraordinarily tough, realistic, muscular British talent that was coming up at the time. Ennis, Ellis, Deegan, Morrison: their uncompromising work took things to a new level, narratively and visually. Bryan, in particular, had a style that breathed with an intensity and realism that honestly I hadn't seen since the early days of Neil Adams. We had corresponded a bit, and decided to meet up in London. And I was scared. I thought, 'This guy's gonna be a bruiser. He's gonna take me on a pub crawl and start a bunch of fights. I'm gonna lose some teeth.'

Several hours later, as we sat over a lovely dinner and Bryan discussed his children, fine wine, and how his real dream was to conduct a symphony orchestra, I thought "Boy, you just never can tell." You never can tell from the dynamic and almost hyperbolically epic work that Bryan produces that he is a gentle, meticulous, and thoughtful soul, whose most frightening aspect is his dead-on Brian Blessed impersonation.

I think that ultimately the key to Bryan's talent is exactly my original misapprehension. His work is notable for its epic quality; for its extraordinary vistas. This is the man who helped Warren Ellis electrocute God's brain. He can bring The Big – in the Authority, in *The Ultimates* – like nobody's business. But the thing that makes it more than just steroidal nineties X-book drek is that he is a painter of life. That he is drawing human beings. That within these detailed frames, which make you believe that a giant man can walk the streets of New York, that a thousand flying people can blot out the sun, that a spaceship 35 miles long can suddenly appear in the sky, the thing that makes it work is the tiny human detail – the captured moment of lips, of tongue, of eyebrow, the crook of a finger, the attitude of a hip, the drape of a uniform over the shoulders – these things are absolutely detailed in such a way that make these vistas believable. That giant man is physically going through the same pain or joy as that tiny wasp woman – (and there's no more harrowing sequence in the scene in which Hank beats Jan up in The Ultimates, because it's two people – it's two human beings). Although the work is always iconic, there is no shorthand to it – it doesn't just rely on icon. There's depth and humanity and subtlety inside every iconic frame – and that's who Bryan is. He has a beast in him (and nobody ever made a scarier or more real Hulk). I believe that Bryan, as much as he is anything, is that Hulk. He is the gentlest soul; he is the most articulate collaborator. His involvement in the stories he helps the writers create is much deeper than most artists. He's a thinker, obviously an extraordinary craftsman, but there is a beast inside him. I think we are all very lucky that the beast only comes out at the end of his pencil, because it is a monster to be regarded with awe. What I know about Bryan's process is all of nothing. I hold this book as would any avid fan, or aspiring artist, to learn the secrets of someone that I respect enormously, who has upped the game of his medium in the way that so few artists can claim to do. I think that anybody serious about comic book art, or even remotely interested, cannot help but be fascinated by the process of a man who creates life on such a large, and such a small scale. So read on. I'll beat you to the end.

Introduction

Comics were my underage drug habit. A small newsagent in a sleepy City in northern England was my dealer and every page in every comic I bought was my high. I kept them in an old suitcase under my bed and every night after all the lights went out and the house was quiet I'd pull out a blind handful and devour them all over again. Every page seemed like an injection of excitement and adventure.

It must have been a habit, as I'd even buy the ones I didn't like and read them with just as much evidence of need. Every issue was a treasure trove of imagination and wonder.

I loved the stories. Superman was moving planets and the Atom was fighting ants. All Star Squadron gave me a lasting interest in World War II and Wonder Woman was promoting world peace by hitting people.

The newsagent was right next door to the cinema and I could run straight from seeing Christopher Reeve bringing Superman to life to pick up the latest issue of the Superman comic drawn by Curt Swan or if I was really lucky, Jose-Luis Garcia-Lopez.

I loved cinema too, of course. The 1970s and early 1980s was a wonderful period for genre movies and big ideas. I would see *Jaws, Star wars, Superman, E.T.* and *Star Trek the Slow Motion Picture* as many times as I could scrounge the money to do so. Tom Baker was being marvellously over the top as Doctor Who, making my Saturday evening boiled eggs and toast the best meal of the week.

It was imagination that was the real hook though because these things weren't just an entertainment to sit back and enjoy, they were an education and they taught me about stories. They showed me what I could do with my own imagination and made me want to try it for myself.

Movies seemed impossible. They were

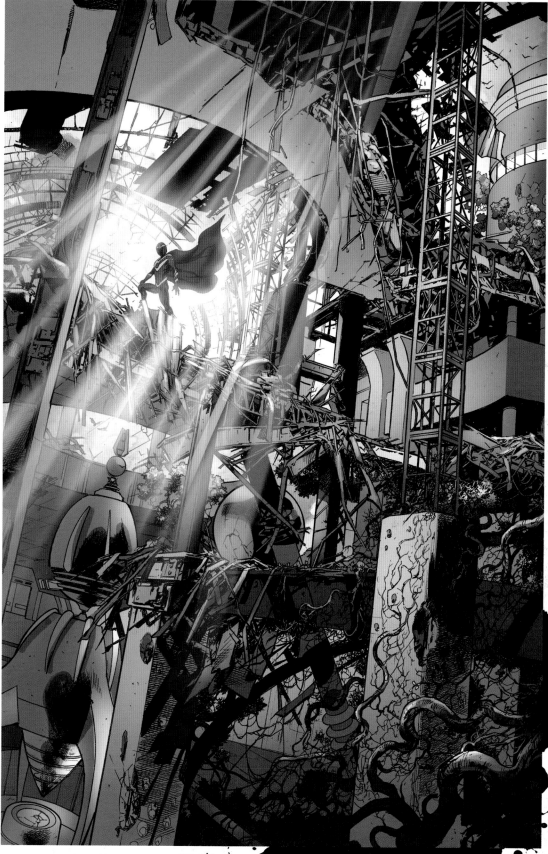

Through the years

I got my first professional commission in May/June 1987, around a month and a half after my 17th birthday. It was for a weekly children's comic called Action Force, *which was published by Marvel UK. Since then I have worked on a series of commissions, both for Marvel UK and US, as well as producing magazine and book covers, such as this one opposite for* Soon I Will Be Invincible.

made in some distant mythical land and like TV you had to be a grown up to do them for real. Even watching them you had to share with the experience with hundreds of other kids who obviously couldn't possibly like it as much as I did; but comics were different. It was a personal relationship, one-to-one, just Superman and me, and at fifteen pence per issue he was a cheap date.

What really made the connection with comics more than film though was that it didn't need any expensive equipment, a huge cast of people or huge amounts of money to tell stories about a baby sent from an exploding planet who learns to fly and saves the world from evil everyday. All it needed was some paper, a pencil and a little imagination.

I had all three.

Thirty odd years later, I have more skill and experience but every time I pick up a pencil and stare at a blank sheet of paper ready to tell another story it's still the same excited boy looking for his fix.

If you bought this book because you hoped I was going to tell you how to draw comics then I'm afraid you're going to be disappointed.

I have been drawing comics professionally for nearly twenty-five years and I might just be getting the hang of it. The thing is, there are no big secrets, no easy short cuts and no clear routes to success; believe me I've spent nearly twenty-five years looking for them. What I think I can give you though is a rough guide to the way I work and suggest things that might be helpful along the way.

There are many ways to solve the problems you'll face whether it's storytelling, composition, lighting or figure work and each solution will lead you in a different direction every time. My way of doing things isn't the only way of doing things and every artist I know has their own methods and their own solutions to problems. We develop each possible solution as we learn and gain experience. In order to gain your own experience, however, you have to start drawing somewhere.

Here's how I do it, I hope you find it useful. It's equally useful to take what you may pick up here and use it to help you analyse other comic-book work. By doing so you will continue to learn how we all do it. Better still, go and do it YOURSELF!

Exclusive cover art for Empire *publication, featuring the Marvel movie characters.*

Commissions for Action Force, Dr Who, Transformers, *and an* SFX *feature on superheroes.*

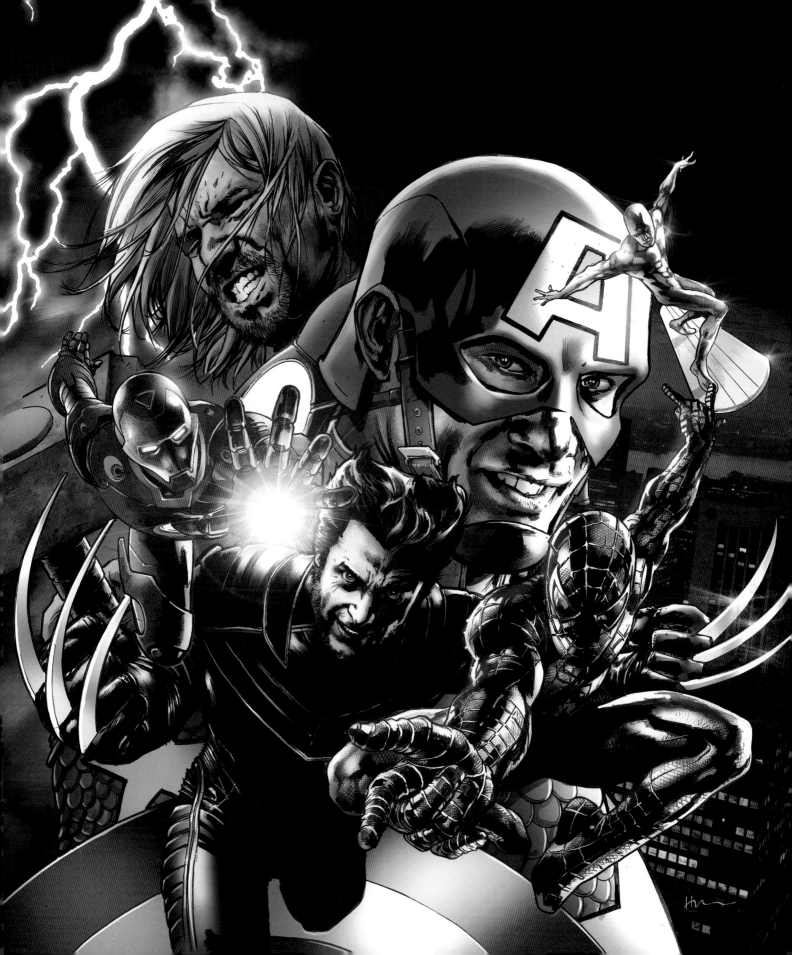

The workspace

Where you work can be as important as how you work. I'm on my sixth studio in twenty-three years and, though the building and room layout changes with each location, they all have certain things in common.

Each has been a dedicated space for working: no TVs and no sofas. That stuff is in the lounge for when I'm ready to relax; in the studio is everything I need to WORK. Of course I have a nice big drawing board and comfortable chair but I also have plenty of other desk-space as I don't do everything at the board. I have a light-box for tracing off layouts, an area dedicated to my computer equipment and plenty of book shelves. Most of all I have plenty of light.

As fancy as this all looks though, I started drawing comics in the corner of my bedroom in my parents house all those years ago, and all you really need is a small, permanent space where you can keep all your drawing stuff. Pens, paper, pencils, brushes and a board big enough to hold the paper you're working on. It doesn't have to be elaborate or expensive. Most of the time I use a piece of roughly cut chip-board leaning on the edge of my desk. Cheap, cheerful and comfortable.

Your computer doesn't have to be the fanciest and most expensive on the market, but it should be able to store all of your images digitally, and have an editing programme such as Photoshop, so that you can work on your pieces. A flat bed scanner is also a good idea for scanning your images into the computer. It is also handy to be able to use your computer for looking up reference shots online when something comes up that you want to check.

Where and how you work is entirely up to you, so your main priority is to make sure that you're comfortable and have everything you need to hand.

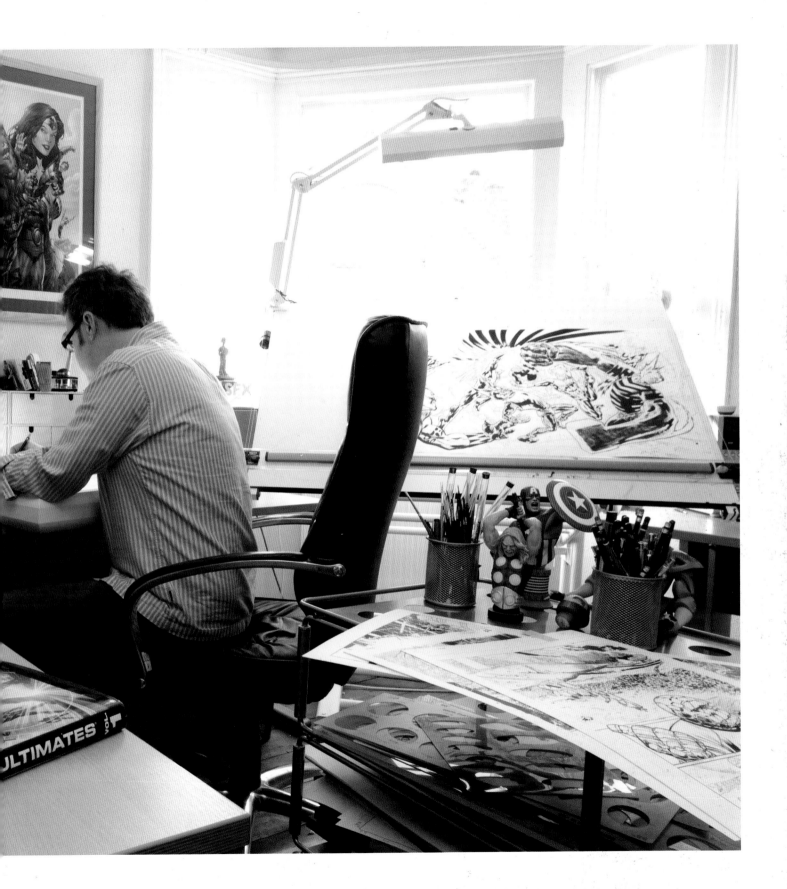

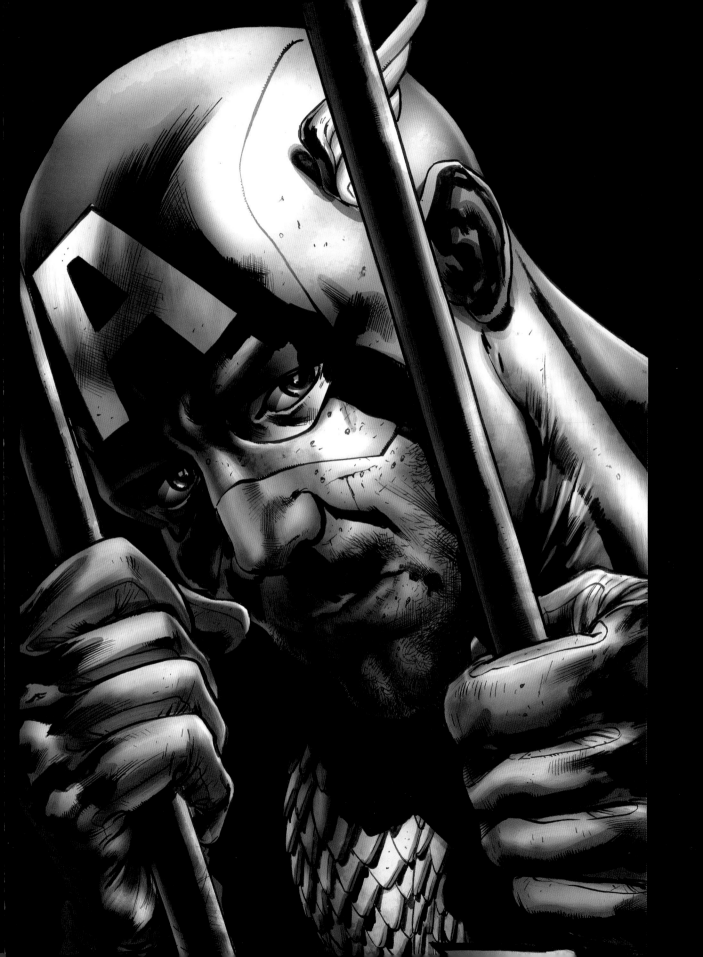

Storytelling

I don't consider myself to be an artist, or even a comic artist. First and foremost, I consider myself to be a storyteller. It always has to be about a story. Comics are nothing more (or less) than a visual storytelling medium; if you just want to draw pretty pictures then be an illustrator, painter, designer or something else that doesn't require you to tell a story. Comics need this from beginning to end. I'm not trying to be brutal with you but if some part of every decision or choice you make in your comic-book drawing isn't made because it aids the storytelling, then you need to make another one that does. If there is any single 'rule' to comics it is that you use every picture to help tell the story and, regardless of what some writers believe, it really is the images – not the words – that are the primary tool for delivering the narrative to the reader.

Having been falsely accused of being a traitor, Captain America has been forcefully arrested and imprisoned.

The process of storytelling

As ever, there is more than one way to flay a feline, but here are some things to help you tackle the story you're going to tell WHO, WHAT and WHERE are the bits of information you need to deliver in your images? Is it clear who the characters are? Are they consistently recognizable from panel to panel. Is it clear where they are, what environment they are in? When you change location, is it clear that you have done so? What actions, events, or movements are the characters involved in?

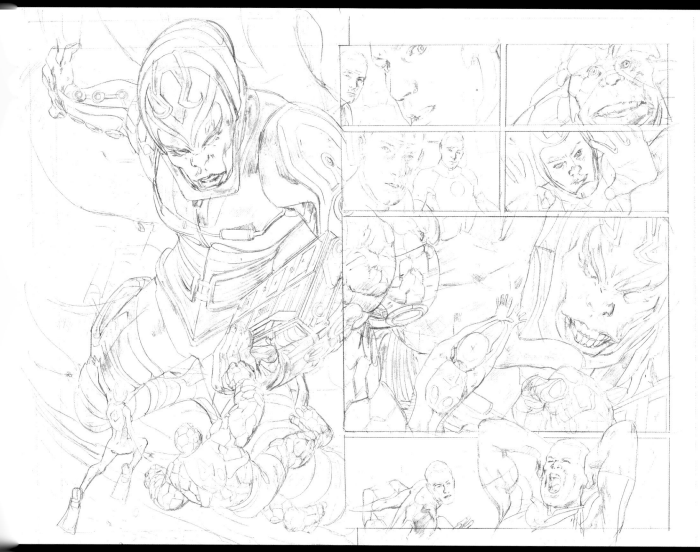

The artist as storyteller

t is the artist's job to clue the comic's reader in o who is doing what, and the initial read-through f a manuscript is when the story starts to

panel sequences. The panels, the sequence and the images within the panels need to be composed in a way that will direct readers at the required pace across and down a page, picking

In addition to this, the artist needs to be able to draw identifiable characters and environmen consistently, and to instantly inform the reader what these characters are doing.

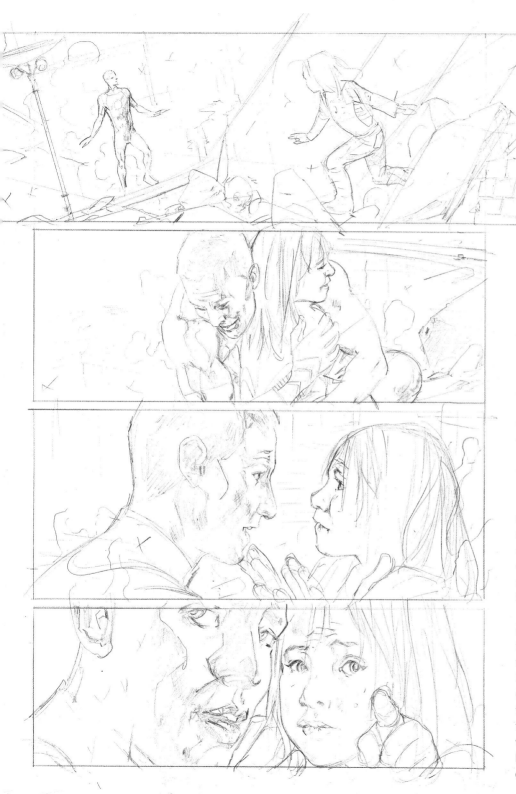

These two sequences from the **Fantastic Four** *suggests both movement of figures and 'camera'. Just like in a movie storyboard there has to be some logic to both the figure movement and the 'camera' movement. Continuity of movement and character placement is essential so that the reader isn't jarred or confused by changes in position.*

Panel composition

At this point in the process I am trying to decide what kind of shot each part of the story is going to be – whether it is going to be a long shot, a close up, an action shot, the best camera position etc. These are the early decisions that you need to make as the storyteller. These have all become a subconscious, instinctive process to me, and that is something that comes from experience and having done something so many times. As a tip, however, I find that if you can understand the emotions that you need to get across in each particular part of the story, and you can understand the direction of the plot, then as long as you make sure that your composition serves both of those things, then it will generally work.

You always have to keep pushing your abilities or your storytelling will never improve, and if you work on a series with the same characters for a long period you will find yourself being asked for many similar or repeated things. The only way to keep it fresh is to keep doing it new ways.

There are key things to look for when you are setting a scene or establishing a shot, so that the reader knows where they are, and who they're dealing with. Adding a particular lighting or mood, or showing people's facial expressions all help to tell the story. And that's the key – whatever you draw you always have to be servicing the story and telling it in the way in which it needs to be told, rather than limiting the representation of the story to your drawing abilities.

uisualisation

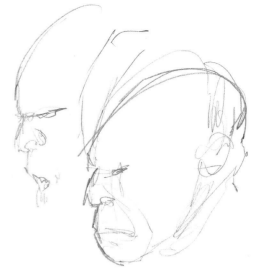

Whenever I read a script I see it playing before me like a film. Reading the words in the script conjures up panels and characters in my mind, and it is at this stage that I really begin to visualize how the story is going to pan out on the page. Rough doodles are an excellent starting point.

How do the characters look? Do we know them already, and do they therefore need to look a certain way, or are they completely new to us?

These doodles are a way of working out the visuals of the script. This means that when I come to pencil the final panels I know that any compositional problems have already been ironed out.

THE BATTLING BOLTS
Bryan Hitch

PAGE ONE:
Panel 1: EXT: A New York City Restaurant, not too posh. Busy street scene.
From Inside: AFTER ALL THAT WE'VE BEEN THROUGH THESE LAST MONTHS, IT'S NICE JUST TO HAVE A QUIET DINNER AS A FAMILY.
Panel 2: INT. Busy Restaurant, and around a large table sit a family having a meal. There's a gran, grandpa, father, wife, son, daughter and uncle (these are the guys from the cover in their civilian clothes).
FATHER: ESPECIALLY TODAY. I MEAN YOU'VE BOTH BEEN MARRIED FOR SO LONG AGAINST ALL THE ODDS AND HERE WE ARE TO CELEBRATE TOGETHER.
DAUGHTER: HANG ON DAD, I'LL TAKE A PICTURE ON MY PHONE AND PUT IT ON OUR FACEBOOK PAGE!
UNCLE: IS ANYONE HAVING A STARTER? I'M HAVING ONE. CRABCAKES. OR MAYBE THE MELON BALLS.
UNCLE (CONT): HEY COME ON, GET ON WITH IT; NOT GONNA BE QUIET FOR LONG...
Panel 3: Dad raises his glass and proposes a toast to the gran and grandpa. They beam with pride.
DAD: HAPPY ANNIVERSARY MOM AND DAD.
GRANDPA: THANKS SON, YOU'RE MA AND I ARE SO PROUD OF ALL OF YOU, STAYING AND WORKING TOGETHER LIKE YOU HAVE. COULDN'T ASK FOR A BETTER FAMILY.
Panel 4: Dad turns as he hears a sound from off panel.
DAD: WHAT'S THAT SOUND? AN EARTHQUAKE?
SON: UH-OH...

PAGE 2
Panel 1: Up from the floor of the restaurant burst the VER-Men – the barbarian, underground rodent men. All are armed with spears, maces and knives. Looking for a kill! Saying various things like KILL MEN! EAT MEN! GRIND BONES! JUICY MARROW! SKIN FOR CLOTHES and so on.
Panel 2: The mum and dad leap into action. Mum changes into The Queen Bee and dad as Captain ThunderBolt (costumes appearing). The Captain vaults over the dining table and the uncle begins to change too, bringing his quantum power to bear.
CAPTAIN: THE VER-MEN! C'MON HONEY, YOU TOO BOB, LOOKS LIKE THIS RESTAURANT HAS A PEST PROBLEM!
UNCLE BOB: WHAT ABOUT MY CRABCAKES?
QUEEN BEE: I THINK WE'D BETTER BE QUICK BEFORE THE OTHER DINERS END

Action of any type is key to comics. What action is going on in this scene, and how are you going to portray it in the panels available?

UP ON THE MENU!

Panel 3: The son sits back to watch the fight, cocky and confident. It's like an action movie! The Daughter looks around and sees something that worries her even more...

SON: MAN, THIS IS GONNA BE GOOD!

DAUGHTER: OH NO...

Panel 4: The daughter leaps in front of grandpa and grandma, erecting some kind of see-through energy shield as she does, protecting them all from the glass that comes flying at them...

DAUGHTER: LOOK OUT GRANDPA!

Panel 5: Big shot past the kids as we see a platoon of SPACE- SKULLS charging through the broken window of the restaurant towards them, throwing other diners out of the way.

THE SPACE SKULLS SPEAK IN WEIRD ALIEN SYMBOLS THAT LOOK AGGRESSIVE.

SON: SPACE SKULLS!

DAUGHTER: POWER UP, JOHNNY...

PAGE THREE:

Panel 1: The SON (Johnny) and DAUGHTER (Jack, short for Jack-Knife) leap into action against the Skulls. She has two swords suddenly and Johnny is arcing massive bolts of electricity.

JACK-KNIFE: ...AND LET'S KICK SOME SPACE SKULL ASS!

Panel 2: Back to the grandpa and grandma. Very calmly sitting amidst all the chaos and violence, sipping their champagne.

GRANDPA: HAPPY ANNIVERSARY DEAR.

GRANDMA: sigh. GO ON THEN. OFF YOU GO.

Panel 3: He looks at her, his eyebrows raised, almost excited.

GRANDPA: REALLY?

GRANDMA: WELL, THEY DID RUIN OUR ANNIVERSARY, CHARLIE.

GRANDMA (cont) SO GO GET 'EM, TIGER!

Panel 4: Grandpa (CHARLIE) starts to rise from his seat and as he does, he begins to grow bigger and hugely muscled.

GRANDPA: JUST LIKE THEY AND THE LAVA-ME DID ON OUR WEDDING DAY IN '64!

GRANDPA (cont): WELL, I GOT THEIR ANNIVERSARY PRESENT RIGHT HERE WRAPPED IN MY KNUCKLES!

Panel 5: Grandpa is now full size and fully muscled; a HULK of a man! He charges in and punches right into a Space Skull. All around him his family fight the Skulls and the Ver-Men.

GRANDPA: GERRONIMO!!!

What panel pacing (size, order and content) are you going to use?

Working out the best camera angle is often about trial and error. Rough out what a key action point looks like from different angles in order to help you to choose the most impactful one. Once you have worked this out, you can begin to think about how that shot will fit into the overall composition of your panel.

Sequential action

When you receive a script the writer will have broken the book down into pages in the script, but sometimes it will be necessary to add pages to a scene – or even to remove them. Sequential action is about the pacing of the story and deciding how many panels to use to tell it. If I can tell it in less space then I will do so.

Controlling the movement

Working out the number of panels to give over to a particular story, or phase of a story, is a fairly gradual process. Sometimes there are times when I am not even aware that I'm thinking about it, and there are others that require a little bit of sketching. Sometimes I just can't see it at all and it takes a bit of working out. One thing is nearly always for certain, however, and that is that the writer of the script will have asked for too many things to be happening in one panel, or they have asked for movie-tricks like camera pans that just can't be achieved easily. So controlling the movement of the story, the panels and the composition of the panels is an absolutely crucial stage in the process and one that you must get absolutely right.

Movement is not always just the physical movement of the objects in the frames; if people are talking while they are moving

Action in action

Sequential action happens on every page with the progression of the story, as demonstrated here in The Ultimates where Cap and Bucky are on a mission to apprehend Baron Zemo. Having the conclusion of the action in the final panel is a natural termination point. Carrying the action over a page, or having it earlier in the panel sequence would be less impactful.

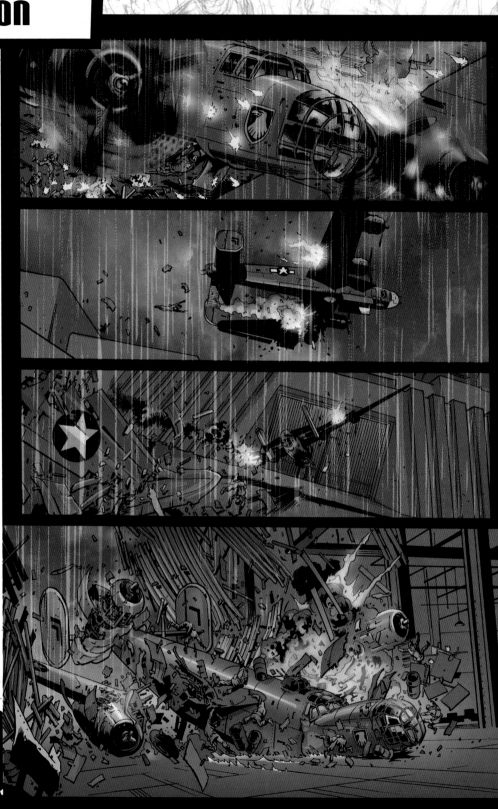

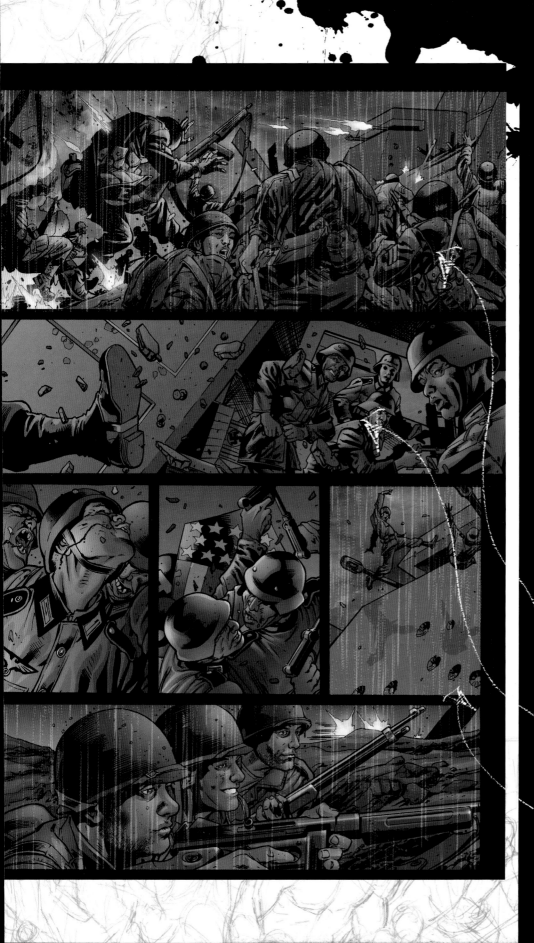

you have to bear in mind who is talking to whom and where they go in relation to the dialogue, so that you read the dialogue in the right order and see things in the right order. All of this needs consideration as you try to decide how many panels each particular story needs. It can be a bit like a puzzle sometimes just trying to figure these things out. The most complicated example I can remember took me a week to figure out.

If the writer has done their job properly and tried to think about the graphic portrayal of their story in the comic then they will have put the speech in the right order so that you don't have to keep flipping sequential images to make the speech bubbles work, and you can therefore create a certain linear sense of movement from one panel to another without too much artistic gymnastics.

It is worth saying that all of this working out is only done with the most basic of scribbles – experience has taught me not to waste my time creating finished drawings before I know that something works. Newbies have a tendency to create a finished drawing after the sketch stage, starting again each time they make a mistake. Work with stick figures and balloon shapes until it's all fixed in your head and you're happy that it all works.

Rhythm of storytelling

I use the word 'rhythm' in a musical sense. Rhythm and beats are used in music to speed things up and slow them down – music has loud bits and quiet bits. Comic books have that as well, and the number of panels you use for a story, the size you use them at and the order they go in all help to create the story's rhythm and pace. The big image is the crescendo, and the smaller preceeding images are all building up to the big moment, with subsequent ones providing the quieter rhythms.

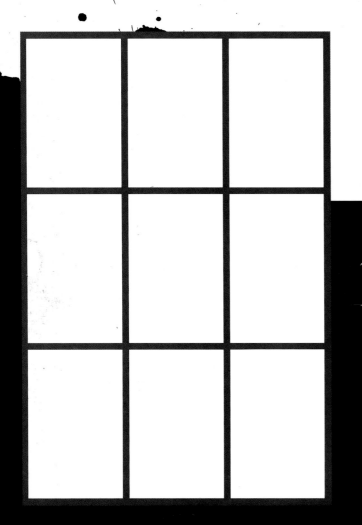

The 9-panel grid

Watchmen *used a page made up of these three lines, of three panels – essentially three beats per bar, in musical terms, and three bars per page.*

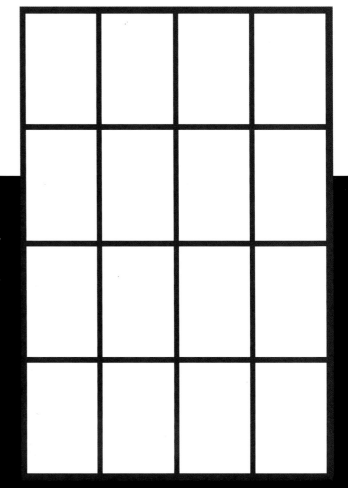

The 16-panel grid

This grid was used in the 80s in a comic called Dark Knight. *Every page was made up either of a combination of either sixteen panels, or anywhere between sixteen and one panel per page.*

Consider the options

The choices of rhythm and pace are usually dictated by what it is that you're trying to do. You cannot create tension by having lots of wide shots, just like you can't use them to create a sense of claustrophobia. You have to know what kind of feeling you want to create within the story that you are telling and choose the shots and rhythms you are using carefully so that you get all of the right information across.

You can break up a comic book page in a very formulaic way so that is is all based on a pre-defined grid of 9, 12 or 16 panels (see below). It

was a big thing in the 1980s to have a 16-panel grid where the panels would then be combined in multiples to create bigger or wider shapes, but it was always based on the multiples of that original four lines of four equal panels.

Even though the comics we do today are not anywhere near as obvious as those examples in terms of how the rhythm is structured, it is still important to keep an eye on the rhythm. If you're working with a separate writer it's vital that you are both synchronized, otherwise it really reflects in the rhythm and experience of the story.

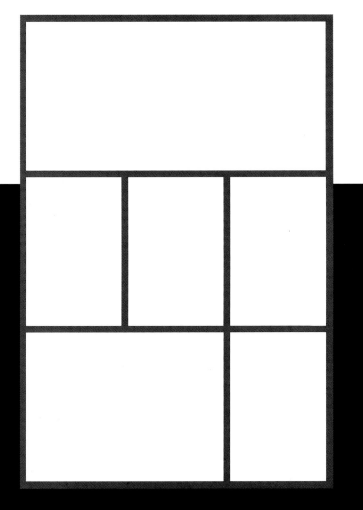

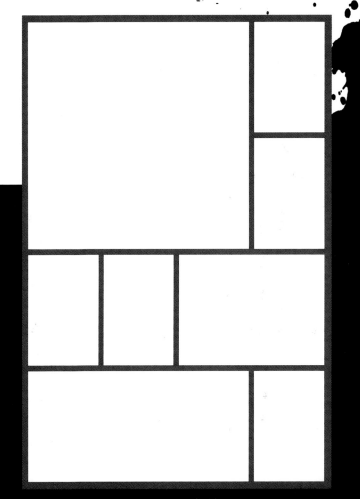

The 9-panel grid

Here is an example of how the classic 9-panel grid can be used to pace the story, and guide the reader through the panels in the order that you want them to.

The 16-panel grid

Made up of the same basic shapes, when the 16-panel grid is combined in different numbers the variation in size helps to provide varying rhythyms according to what's happening in the story.

Bryan Hitch trademarks

It is inevitable that your own style and personality comes through in your work, and that readers become familiar with that. I like my action to be 'big', and the devices I use for this have become known as my 'trademarks'. To me, it's all just part of conveying a story with as much impact as possible.

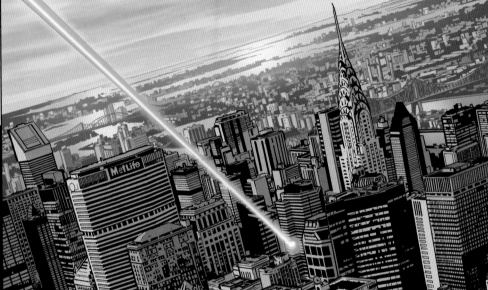

New York establishing shot

Establishing shots make the location of the action a key part of the story, be it a city, a building or a spaceship. This detailed panorama from The Ultimates *provides a level of reality, and is also a useful tool to give the reader a moment of space to breathe and re-adjust.*

1. Establishing shots

Not all comic artists are keen to show the reality of the environment in which the story is set, but to me it is an important part of the storytelling process. It makes the reader feel involved and helps to achieve verisimilitude. If a story is set in New York then I want the reader to experience the awe of walking around Manhattan. I want big shots of the city, which I research using a variety of books and bespoke photographic reference.

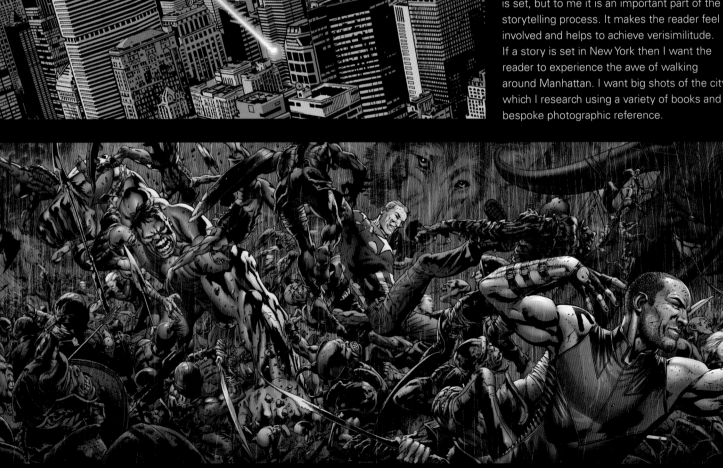

2. Widescreen action

I like my action to be big. My artist's viewpoint is from within the action, not from a peripheral point, and I want the reader to feel that they are being dragged through the action as well. These widescreen shots really put the reader in the thick of the action.

3. Close-up portraits

This is all about choosing a viewpoint to give you an angle of a face that you've never seen before, to get an expression that has impact

and purpose for the story. It can be quite daunting to approach a big, empty piece of paper and start drawing in an awful lot of detail, but you have to be fearless.

4. Detail

I am sometimes told I could get away with putting less detail in my work, but I just wouldn't be satisfied doing less. I put the detail in because it should be there; I see it as intrinsic to my role as a storyteller.

'The' *8-page widescreen shot*

It was coming towards the end of The Ultimates, *a six-page spread had just been done in* Batman, *and I wanted to beat it. The action moves from left to right and the eight characters each have their moment in space to clarify the layout of this mega conflict scene. It's one of the most fun pieces I've ever done. The satisfaction of unfolding each of the printed pages to reveal the whole scene is hard to beat.*

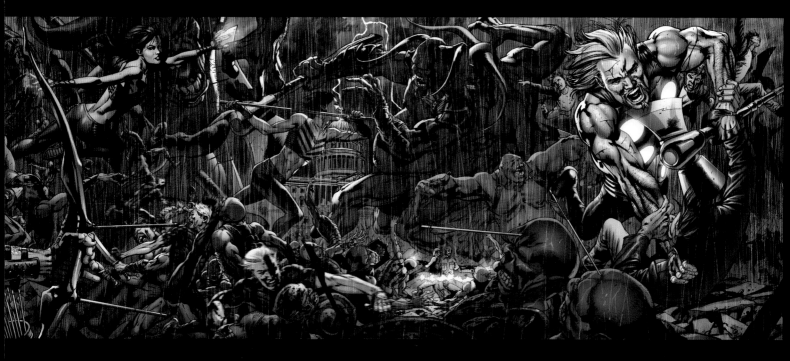

Storytelling

This sequence from the *fantastic four* was originally much shorter, but I expanded it to change the pace of the whole story. I wanted to take a moment within the action and drama to inject a little bit of wonder, and take time to enjoy the elements of the fantastic.

We open with the children, Franklin and Valeria, testing out the flying jackets that they got as Christmas presents.

Next, the camera is pulled back to show the Scottish loch that they're flying round (they're spending Christmas with their uncle). Showing this perspective really sets the scene, and adds to the drama and excitement of what they're doing.

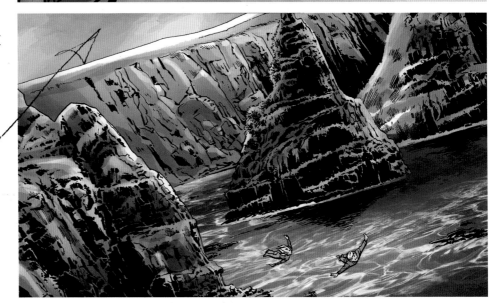

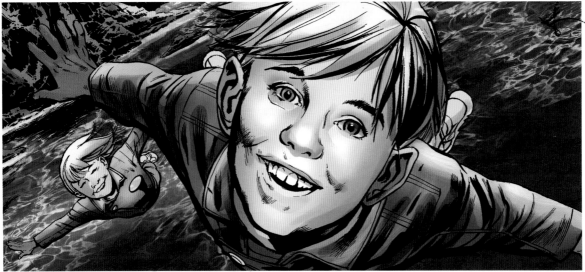

Franklin and Valeria then fly up and out of the loch. Showing the scene from above conveys not only a sense of height and scale, but of swooping movement. It also continues the path that they would have flown from the previous panel.

Having taken a bounce off their uncle's car they fly off again, leaving the reader on the ground with everyone else. Their mum provides the only dialogue of the scene: 'Don't get lost, don't be late, be back in time for church'. This reinforces the idea that they are just children playing with their presents on Christmas day.

I used the bigger panel (top) because I had so many elements that I wanted to fit in the shot. These panels are a smaller moment and so have the smaller panels, but they are all part of the rhythm and beat of the story.

The whole of this story sequence is paced so that when you turn the page to this double page spread, you get a sense of space. Using a wide shot and having the kids soaring in the open air above the buildings accentuates this, as does the physical space of giving the scene a double page.

If this were an orchestral piece, it would be a crescendo. I was thinking Raymond Brigg's The Snowman, Peter Pan, and when Lois first flew with Superman in the 1978 Superman movie.

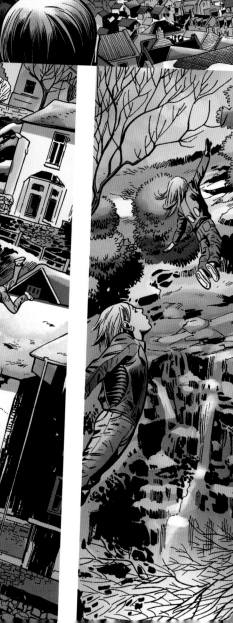

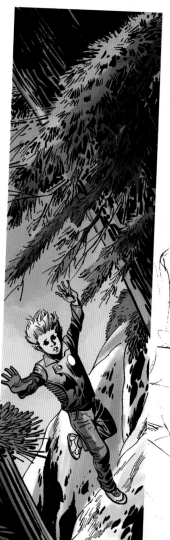

Now it's time to get back to the story so we cut to the smaller panels again. There has been hardly any dialogue in this whole sequence – the story is all told through the art and the panel composition.

Doing long and tall panels like this means that I'm able to fit in a lot more information on the page and regain the pace of the story. It's all balanced out by the overall rhythm of the action that's gone before, and that comes after.

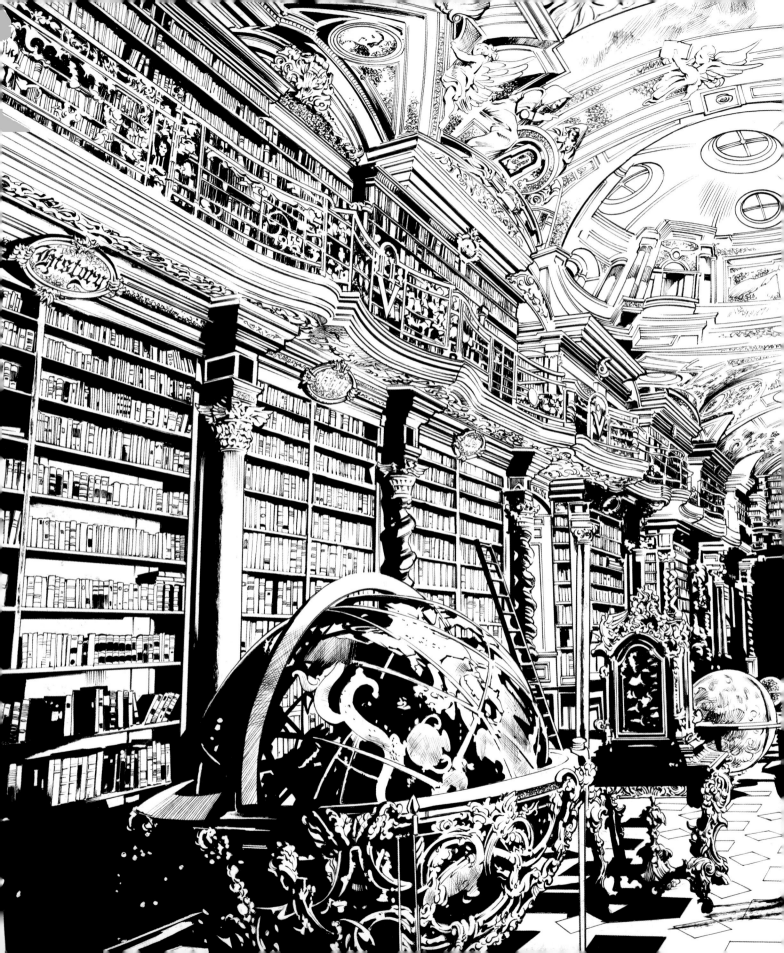

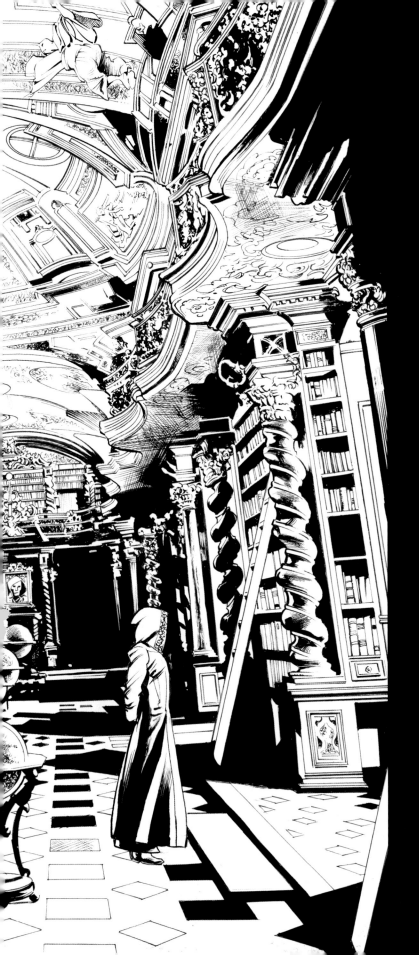

Composition

In any single image composition is the bit where you decide what goes where and, knowing what the focus of the image needs to be, how to make sure the person looking at the drawing sees what you want them to see in the order you want them to see it. Sound complicated? Well it can be a lot to think through, but on comic pages you have anything from one image to six, sometimes more so that's even more to think about! Here are some things I keep in mind when I'm working this stuff out. When we read anything we scan each line left to right, then on to the next line below and so on, top of the page to the bottom. The same is true of panels on a comic page. Knowing how the reader's eye is going to naturally scan the page as they read means there are some things you can use to your advantage as storytelling tools.

Dr Doom's study in the Fantastic Four. It's a statement about how fantastic Dr Doom is, that he has this amazing study to work from, rather than any old ordinary place. A library in Prague was used as reference.

Creating roughs

There comes a point, anything from a minute after reading the script to several days after, when I want to stop thinking about drawing the page and actually start to draw it. So the first thing I do is refer back to the scribbly doodles on the manuscript, where I have generally roughed out the panel numbers and shape.

Why create roughs?

The rough stage is where you should solve all of your compositional problems that you need to address, such as basic perspective and construction. You can create as many rough sketches as you want – you can create them on different pieces of paper and layer them on top of each other until you get the effect you're looking for. The key purpose of creating roughs is to get things right before you go to the art board. You don't want to be constantly re-starting your finished piece – if there's one thing that experience has taught me, it's that I can't afford to waste time. This is where you want to be nailing down what the drawing is actually going to look like when it's finished. Use this stage to figure out where things in the panel are going to go, try out different camera angles and perspectives.

Start scribbling

Most of my rough work starts with a blue pencil. You can make an awful lot of mess and do an awful lot of scribbles with a blue pencil which can amount to a messy series of attacking whirlwinds. The reason why blue is used is because traditionally it does not photograph, copy or scan. Then you take an ordinary graphite pencil and start picking out the shapes within those crazy lines that represent nothing to anybody else. You start picking out little bits on them and they start to become bodies, figures and other shapes which are then further refined by the sheet of layout paper that you lay over the top to refine it even further. Draw as quickly and loosely as possible, and get it out of your head while it's fresh and creates energy in what you're doing.

The earlier rough sketches here have more simplicity, energy and promise, and are more effective, to my mind, than the finished piece.

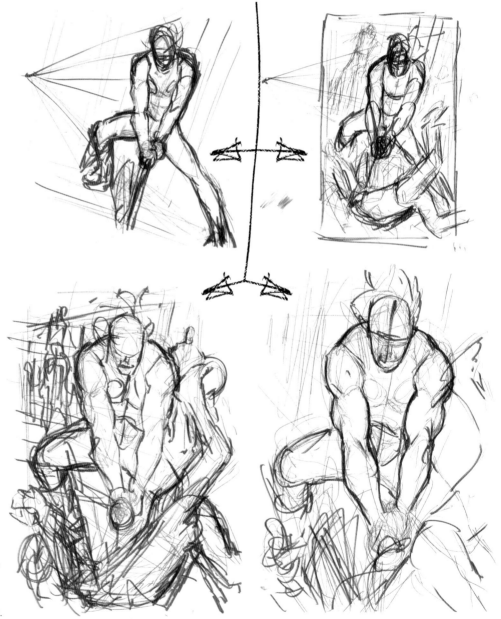

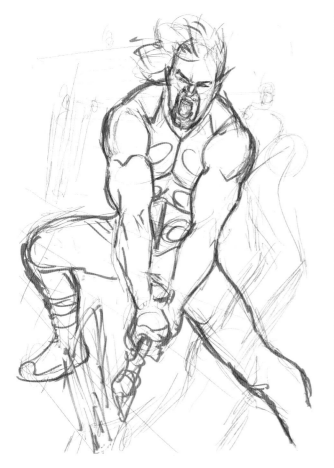

Making sense of it all

After I have picked out my initial shapes with pencil I will get some red marker pens and start going at it with those. Again, I may do several variations, or try out different angles and include different objects in the scene until I'm happy with it. I will then either take it onto the lightbox and tighten and clean it up, or I will create it all over again on a sheet of layout paper. This depends how late in the day it is, how warmed up I am, and how complicated the image is.

At some point in this roughing out process you need to realise that you are far enough along to actually stick it on the art board. I don't generally go to finished drawing at this point, because unless it is an extremely tight layout with all the working figured out, then you will want to get a nice clean layout with all the construction work done but quite lightly. The ideal point at the end of your rough stage is to be able to get a darker pencil and finish your drawing without having to worry about any construction work or problem solving.

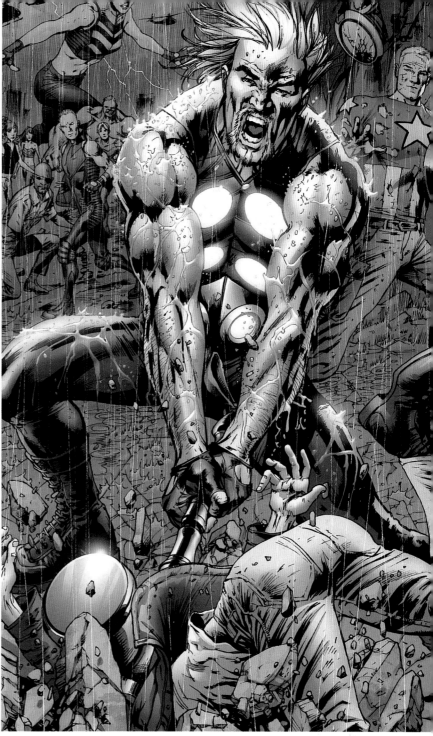

Capturing the first idea

The hardest part of creating a finished piece is trying to capture the energy and spontaneity of the early rough drawings. As you lock the image down with hard compositional rules you are often in danger of losing some of the power and impact. It's hard to carry the promise of a sketch to a finished, perfected, polished drawing.

Camera placement

This is the first thing I think about because it dictates where the perspective and vanishing points are going to be. I have a clear idea of how I want each panel to look from the initial reading of the script, and what follows is an attempt to solve any problems that are thrown up as a result.

The importance of the camera

Where you place the camera is all about how you get the reader to see what you want them to see in a particular order, and how you make sure that from that point you have everything in there that you want the reader to see. There is no single 'right' place to put the camera, and the only one that's wrong is the one that does not give out the information you want and need to convey – who is doing what and where. Learning to make these choices comes with experience. As long as it tells the story it really just comes down to personal choice.

Viewpoint

Imagine there are two people in a room with a table, two chairs and a door. If you have a down shot your perspective will look pretty close to the way it would for a mid-level shot, where on the art board your vanishing point will be pretty much on the centre of

It all starts here

The camera point is the start point for any piece. It determines your vanishing points and your perspective, all of which are vital to achieving a plausible combination.

There were times when I would create all the variants I could for every possible panel, and then couldn't decide which one I should use.

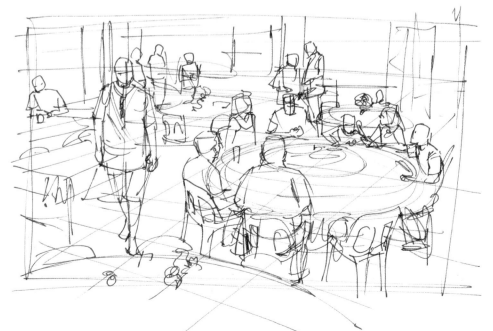

the image. The difference with a down shot is that you are looking right at the top of the characters' heads, so you have to re-think how all the shapes in the room are going to look. A low-level shot means that you are going to have the vertical lines at an angle and going towards a vanishing point above the top of the page. You are constructing the perspectives based on where you want to put the camera.

Setting the scene

This wide-angled, high level shot of the restaurant is the most effective way to establish our location, and who's in the panel.

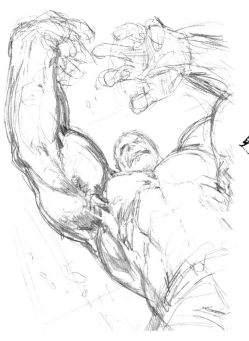

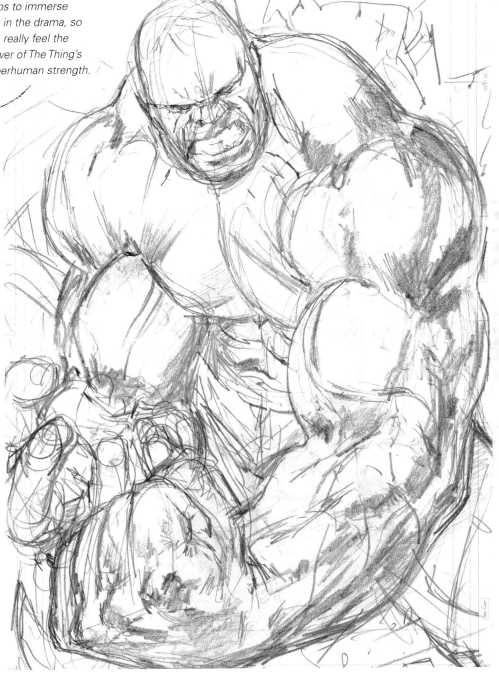

The proximity of the camera to the action helps to immerse you in the drama, so you really feel the power of The Thing's superhuman strength.

Camera angle

Your next decision is the type of shot that you need to ensure that the viewer sees everything in the correct order. The camera has to be in the right place and at the right angle to get everything in the shot – if you don't want the scene to start with a close-up then you need to make sure that the camera is far enough back. Alternatively, you might want to start with the action feel of a close-up, perhaps with an impactful dialogue, and then pull back to see them speaking to everyone else, or to see everyone's reaction to what they're saying. Whichever angle and placement you choose is entirely up to you and is driven by the information that you need to get across in that particular panel. Try out different options and develop your skill at drawing from different angles, otherwise you're going to be restricted and formulaic.

Consider the camera angle's effect not only on the perspective of objects towards the vanishing point, but how anything in the foreground is going to be affected, especially in action shots that include punching fists or kicking feet. Foreshortening can be a tricky skill to master, but again is something that you have to be able to do in order to create impactful comics.

In or out?

The difference in impact created by lowering or raising the camera angle can be huge. Being so close to the camera puts the reader in the thick of the action – sometimes the reader needs to get a wider picture and an overview, which is when you would use a widescreen angle. The reader should feel as though they're participating in the action somehow, rather than just reading it – they should never feel like they're at a theatre show and all of the action is happening on a stage some distance away.

finding focus

The focus in a panel is always going to be the information that you are trying to get out, whether it is somebody speaking with the focus on their dialogue, or an action scene. Your starting point has always got to be where you want your reader to look.

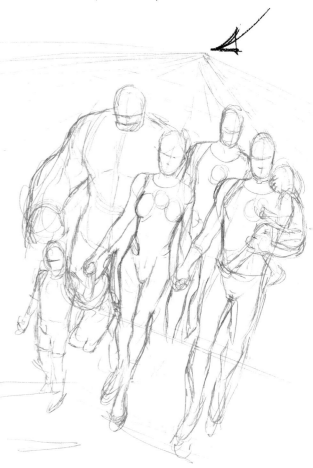

The vanishing point doesn't have to be on the person that you want to be the focus

Keeping it clear

The most simple point of focus is a person in the panel. You don't want the dialogue balloons going off to something that you cannot see, because that is lazy and should be avoided. Keep it clear and simple, and resist the urge to over complicate these things. Ask yourself if the focal point and the action is clear? If it isn't, then it needs to be. Vanishing points and perspective help with this enormously, but remember that the vanishing point doesn't have to be on the person that you want to be the focus – think more laterally than that.

The object of focus needs to be within the focal range of the perspective, but you can use other devices to guide the viewer's eye around the composition. Design your panel so that all of the other elements lead to the focal point, rather than out of the panel. Pipework, debris, cars or people pointing are all a good

way of leading the eye to the focal point of the panel. Of course the easiest thing is to have nothing but the focus of that panel in the panel, but you have to deal with complicated compositions at some point. Don't put anything completely gratuitous in the panel, only that which helps your composition and tells the story better.

The more drawing you do the more instinctive this process will become. It is only by trial and error and lots of practise that you will establish what works and what doesn't work, and how you will be able to translate the image in your mind faultlessly onto paper.

It's not rude to point

Having the characters all pointing at the action leads you naturally to the focal point.

The characters here are arranged in the order in which they speak, rather than in the usual left to right. None of the characters are the point of interest, and the perspective is used to ensure that everyone's in the correct plain.

The movement of the characters leads you to the focal point. Here the perspective doesn't help provide you with the focal point.

What's the point?

There are various ways of guiding the reader's eye to where you want them to look.

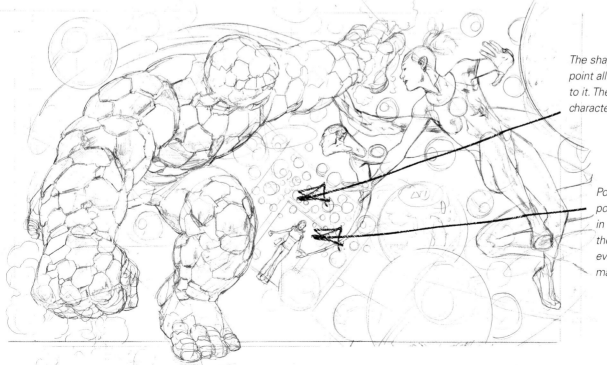

The shapes around the focal point all help to guide your eye to it. The movement of the characters also draws you in.

Positioning the vanishing point of the perspective in the image behind the focal point leads everything to it, no matter where you look.

Character placement

You need to get all of the characters into the panel so that the reader can see who's in the scene, where they are and also who's speaking. It is a compositional problem that will arise all the time and that you will constantly be thinking about – and there will not always be a straightforward solution.

Do not have more than three people speaking in the same panel.

Rules of thumb

There are two golden rules with character placement that the writer should always try to follow – do not have more than three people speaking in the same panel, and if three people are speaking in the same panel they should not have more than one word balloon each, with the possible exception of the third speaker having two balloons. There are times when a writer has asked for so many people speaking in panels and multiple balloons from each character that it is impossible to work out a way of putting them on the same image.

You will see in some comics that complicated cross dialogue between characters is tackled by just having the two characters at either side of the page, with a list of alternating dialogue balloons down the middle. It is always worth challenging yourself to come up with a better solution and drawing it panel-by-panel, otherwise we come back to your ability not really improving and your skills stagnating.

A large amount of dialogue, and where that dialogue is going to go, is as much an important space element in your picture as the figures and the action taking place there, so it is always worth taking the time to really sit and think about how best to tackle the problem. Hopefully the writer would have done their job well and constructed the dialogue per panel in a way that can be drawn by you, so that you do not have to work out the nightmare of trying to figure out how speaker one can speak three times and speaker two can speak twice, and you won't have to have overlapping balloons obscuring much of the artwork.

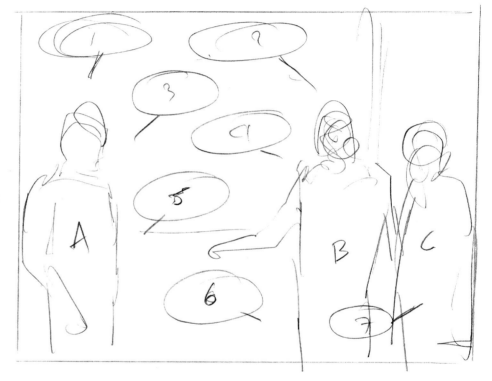

How to tackle it

When you have three people speaking in a panel you need to line them up in a certain way to enable you to get all of the information across to the reader. If you line the characters up then character A can speak, and because you have put him first he can face character B. Place them carefully and you will have a space between character A, character B, and character C on the right-hand side of the panel. Character C also has room on the very far right side of the panel for one extra balloon of dialogue, if you wanted it. That is about as far as you can push it, and you generally sacrifice space for impressive composition as a result.

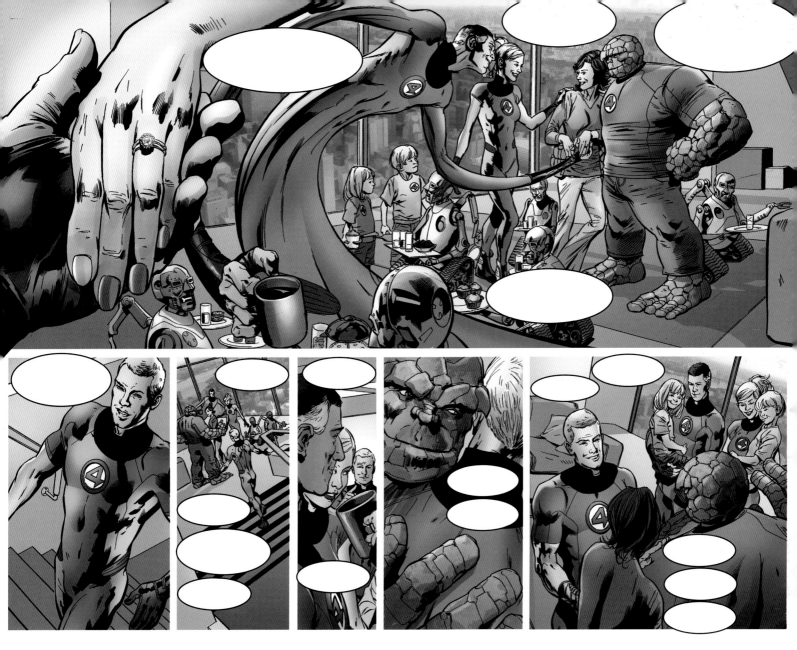

Balloon placement

'Dead' space in the image is the ideal place for your dialogue balloons – on people's backs, nondescript backgrounds etc. Basically anywhere that they don't interfere with the information that you're trying to convey.

The balloons can be placed in a variety of places at a range of sizes. They can be stacked or be on their own. As long as you order them from left to right in the order in which you want the reader to see them then they will work. Dialogue balloons on the far right of the panel will lead the eye naturally right out of that particular panel and on to the next.

I always have the balloon and character placement in my mind from the early compositional stages, but I no longer mark up where I want the balloons to go. Experience means that the writer will either specify where they want them to go, or the letterer will be trusted to place them in the best place for the story. It is rare that I see my work after finished pencils to have the opportunity to specify things like balloon placement, but as the artist and storyteller it is still my responsibility to compose the panels in such a way that the story can be told and that none of the information is obscured.

Multiple everything

As this scene from the Fantastic Four demonstrates, if you need to get multiple characters into the panel you need to think carefully about your camera angle and the characters' placement within the shot. Organising your composition to allow for speech balloons is an essential part of being a comic artist, and you don't want the artwork being obscured. Consider the amount of dialogue that the character has, and allow for that balloon size.

Graphic blacks

There are times when you want to use a lot of big foreground black shapes, or create an impression of a large environment or a large scale object, and graphic blacks are the perfect device to enable you to do just this.

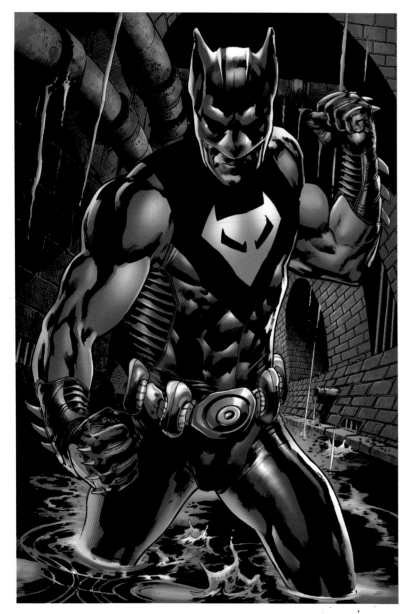

Black Wolf

Strong blacks are important to add solidity to the form of an object or a figure. I don't go as far as Mike Mignola, but I do like to use a lot of strong blacks rather than a lot of rendering.

You see it all the time

People in the foreground of scenes are often dropped into silhouette – it happens when you are walking through a tunnel and you can see the detail at the end, but the tunnel itself provides a silhouetted framework and the figure inside the tunnel will also be black, but silhouetted against the end of the tunnel.

When using graphic blacks in your comics you don't need for your image to have black on top of black – compose your image carefully enough so that there is enough of the shapes visible across each other that the brain can work out what they are. It is amazing how little you need of a human figure for the brain to recognize it as one.

Night shots

Where graphic blacks come in really handy is when you're doing night shots. It's a bit of an epiphany when you realize that you don't have to draw lots of detail in buildings and can just simply make lights out of a sea of black.

In the pre-digital era the solid black was more important as printing was poor, meaning complicated rendering wouldn't print well and colours were limited. The graphic black area was a useful tool. Now, with such colour techniques available with Painter and Photoshop, you see newer artists using black less and letting the colour do more work. I see black as being as important as ever and, when combined with the great colours available today, an unbeatable combination.

Be wise

Don't just use graphic blacks as a way of avoiding drawing something, or to not have to add detail. It is a useful tool that can add gravity and impact to your image, but use it wisely only to enhance your composition.

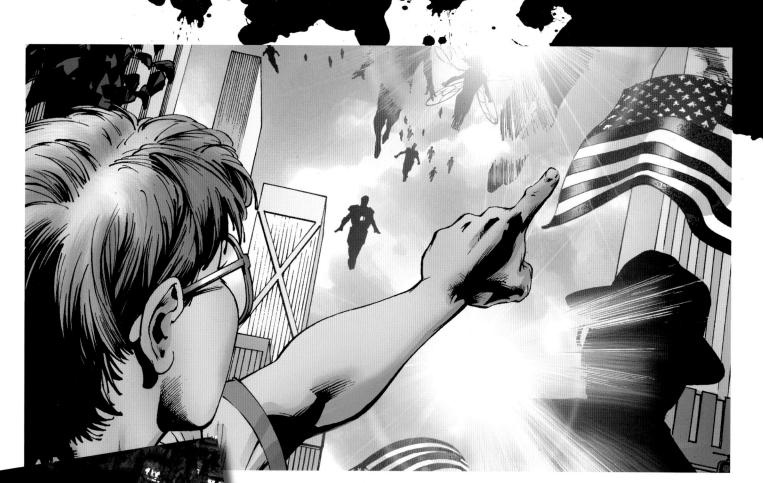

Negative drawing

Your whole panel is in black, and you simply draw in the windows lit up. The most effective way to do this is to take a night time cityscape photo in high contrast and, on the lightbox, pick out the windows. All you provide for the inker are outlines, which they then ink around and fill in the blacks.

Rush jobs

This piece (above) was a very last-minute job for an SFX feature on superheroes, so I needed to save as much time as I could. Having everything in silhouette means that time can be saved by not having to design costumes and outfits, while the large figure in the foreground helps to fill the piece.

Composing environments

You need to use lighting to create mood. As ever, you need to include it for storytelling purposes rather than just for the sake of it. What element of the story requires you to create a mood? Is it claustrophobic? Night time? Cold or hot? Whatever the script asks for, you choose the lighting to create that effect.

The cold environment has defined the blue and white colour scheme.

Location, location, location

Having the foreground figure and rock in graphic black means that the colours of the mountains and sky in the background have more impact.

Colours

You start thinking about colour and lighting in broad strokes quite early on in the drawing process – when you're planning your composition as a whole. When and where the scene is taking place is the main motive for your subsequent choice of colour. For example, if your scene is taking place during winter, or in a snowy landscape during the day, then you know it is going to involve an awful lot of blues and whites. If it is daytime you would probably keep the work very clean, because it is a crisp and bright light, and those blues will give you a lot of the mood, making it very light and open.

Night scenes will be different, because there will be lots of skeletal shapes (trees, for instance) and blacks, but it will all be done with lots of deep colours such as blue and purple, as well as whites and yellows. There will be lots of shadows on clothing, faces and objects.

A summer's day, a desert setting or a place near a fire or explosion is going to have a predominant colour scheme of warm hues – oranges, yellows and reds – while the specifics of the scene and story dictate what kind of lighting you choose within your basic colour framework.

Remember that the final colours are largely the decisions of the colourist in professional comic art, but you give them directions and ideas about what you're looking for and the feel that you're aiming at. Both the colourist and you still know that it's going to be a warm or cold scene, a dark one or a light one.

References

It's very hard even for accomplished artists to come up with scenes off the top of their head, and that is where your reference shots come into play.

Your script will dictate the location of your scene, but using photographs – either from the internet, books or your own collection – are an excellent resource. They can help to spark your imagination, and provide those all-important details that help you convince the reader that the story is actually going on where you say it is.

The scene opposite, in Times Square, New York, would not be anywhere near as plausible without all of the trappings of the famous location. Always remember that, first and foremost, you're telling a story, and one that has to be believable, otherwise your viewer will not be convinced and will put the book down. It's all about verisimilitude – more about that later.

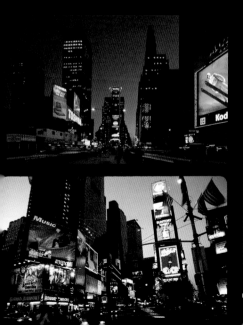

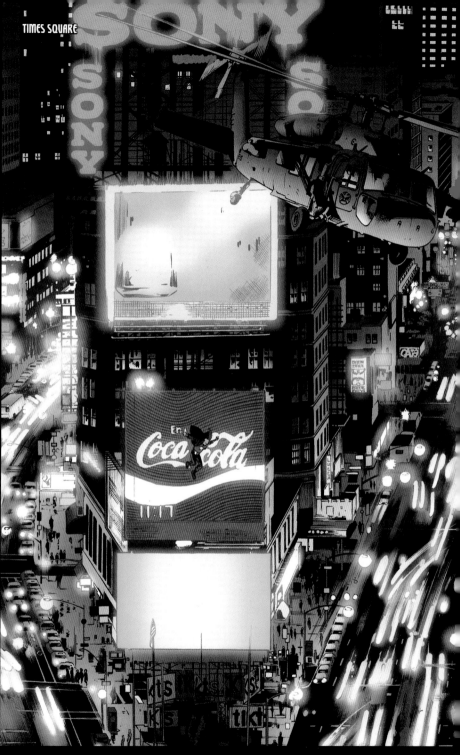

Times Squared

This image combines an action shot with an establishing shot, so having Captain America jumping out of a helicopter over New York meant that it had to be an iconic, recognisable location.

...composing environments

Using pictures of bomb damaged cities and craters in the road was a good reference point for this cover.

Cover story

This image was designed as a cover for the Fantastic Four. I wanted to imply that there were dark secrets revealed inside the pages.

Before the four

This image was used as publicity for the first Fantastic Four film, and was the first time that I ever drew the characters. It pre-dates my work on the book by a couple of years. New York was where the film was set, so it seemed the most natural environment, while I had to leave room for an actual article to run down the left side.

Achieving verisimilitude

When reading anything fictional you are required to suspend your willing disbelief. As a storyteller you not only have to do the same, but you have to tell your story in such a natural, plausible way that your reader doesn't stop and realize that what they're reading is utter fantasy. I am not saying that everybody has to go for a sense of verisimilitude, but that is my thing. I like to make my comics feel as though they are happening as close to reality as possible.

If you draw attention to how ridiculous something is then you are going to lose your reader. Everything you are doing in a comic is presenting the implausible as plausible, so from the minute you pick up your pencil everything that you do is bent towards making it real.

How to get it

For me, achieving verisimilitude comes not only from my attitude, but by paying attention to the detail of a shot. If your character is flying through New York then you choose and research the buildings they're going to flying past to ensure that they are recognizable and real. Whatever the environment and the objects in the story you have to research them so that you can portray them as closely and as realistically as possible. It all adds to the reader's experience, and their willingness to believe what you're telling them.

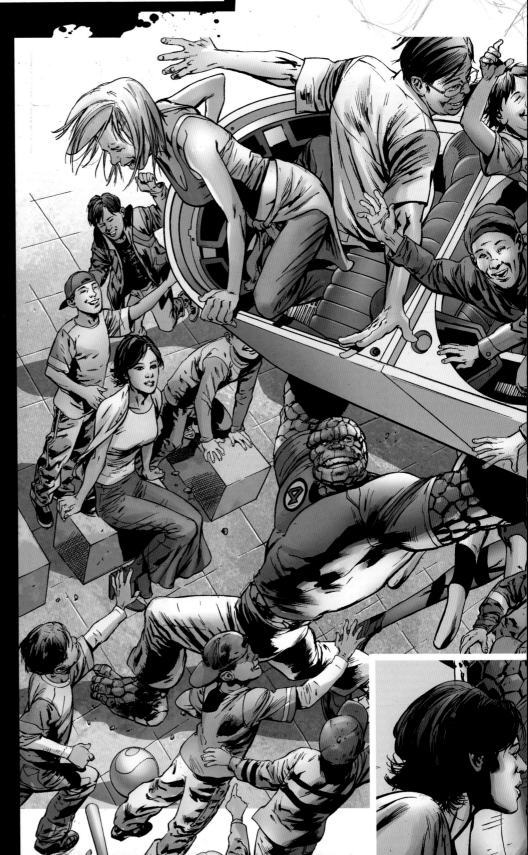

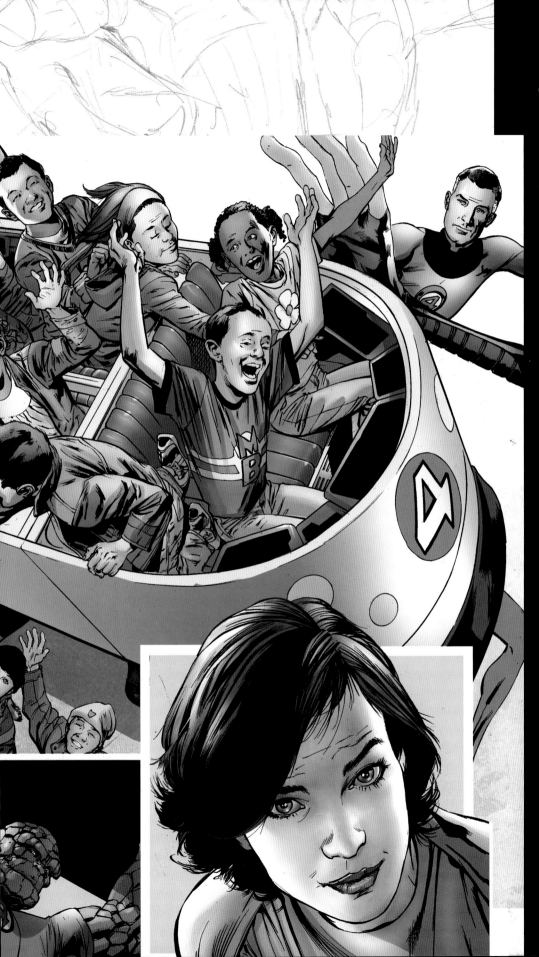

A big rock man lifting a flying bathtub full of school children over his head is a fantastical concept. To make it believable you have to pay close attention to the detail, such as the clothing, facial expressions of the children and the naturalistic reactions of the characters to the scene. It is that detail which provides the appearance of reality.

It's the norm

Take for example the *Fantastic Four*. I'm drawing characters which include a man who is able to stretch his body the length of fourteen football pitches, a woman who turns invisible, another man made of rock who can still apparently walk and move just like anybody else, and a guy who sets himself on fire on a regular basis. This is the *Fantastic Four* and this is perfectly normal to that story. You do not draw attention to how silly it is, because if you're thinking that then the person reading it will think 'Well yes, it is kind of silly, I won't read it any more'.

Everything you are doing from the moment you pick up your pencil has to be believable. It has to be read, and the reader has to believe what they're seeing. Verisimilitude is a natural part of any creative process.

That is the only thing I can give you by way of advice – do everything you do with conviction and believe that you believe it. If the *Lord of the Rings* film had been treated like fantasy it would have turned off the larger audience, but because they actually treated like a historical film it gave it a captivating sense of realism.

Composition

Your composition is of course driven by what's happening in the story – which characters are present, why they're there, where they are and what they're doing. As ever, everything that goes into your panel has to be there to tell a story, and it has to tell it well.

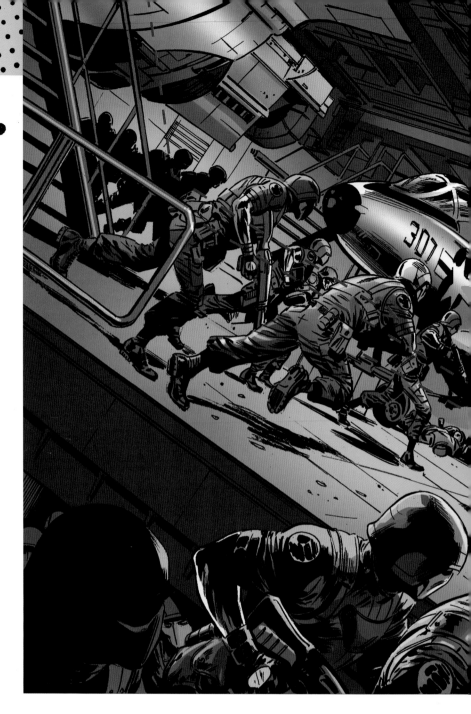

Captain America *Reborn*

This is the first time in the issue that we have seen all of these characters, and as we cut to them they are in the middle of a battle. Immediately there were two things that I needed to address – firstly to establish they are in the midst of a big battle and, secondly, to make the two key characters (Captain America and Black Widow) clear. These heroic characters, along with the bad guys, all had to be visible, in action and the composition itself had to be fluid and dynamic.

Deep perspective

The way I solved the problem of getting all of the information across in this image that I wanted to, as well as establishing the big environment they were fighting in, was to use the deep perspective which pushes you right into the picture. I tilted the vertical and horizontal towards the right-hand side because that then helps to pull you down across the image from your left starting point (because we read left–right). But then of course halfway across that perspective you encounter that really deep central point that pulls you inside the image so that you go across and in.

Rotating dynamic

The first area you pick up on when you're in the vanishing point is Black Widow, and you see this guy with the hammer leaping up with the axe pointing at Black Widow, but the actual arc of his movement will hit Captain America. So the guy right up in the air is the first enemy that you come to, but at the same time the arc of his body points right into the evil Spiderman character and his arm, in turn, arcs right back down to Black Widow. So you have this continuously-rotating dynamic of the core characters, with the lines of the two main rafters above Aries and Captain America drawing you into the action.

Supporting cast

I used all of the other soldiers as cannon fodder to pull you into the action – no matter where you're looking at the picture they

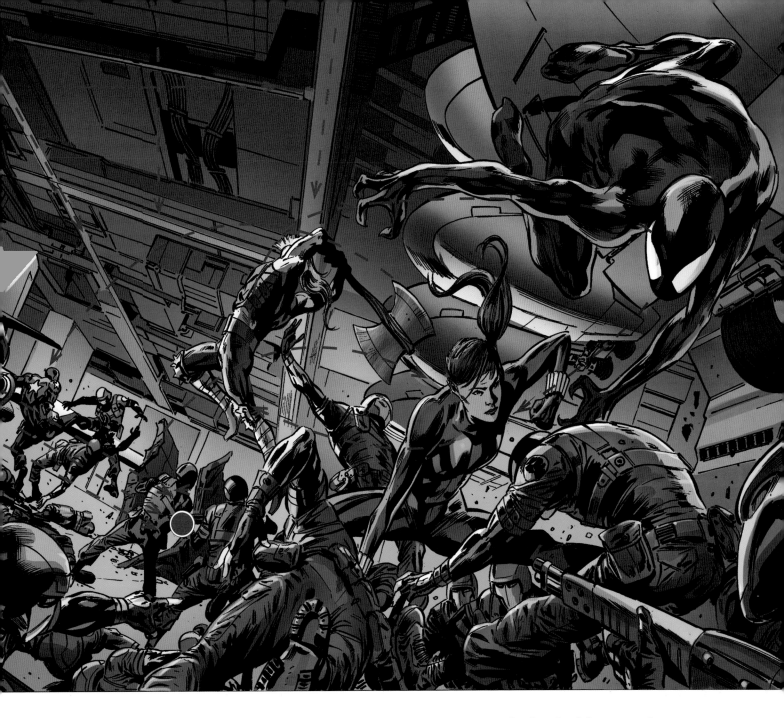

all take you back to that central section, so they're running downstairs, or across, or upstairs. Wherever you look at the picture your eye is always taken to the central area, so you seem to be constantly in motion. It's a static image, but there's a great deal of action happening. All of those compositional choices were deliberate to achieve that result and have something that looked extremely busy and action-packed, but yet is a single static image.

Getting the right perspective

Deep perspective pushes you right into the picture.

Drawing

I never really consider myself as an
illustrator or an artist specifically.
Drawing just for the sake of drawing
a picture or something just does
not interest me. The reason I try to
constantly learn to draw better is
because I want to be able to tell the
story better. All the drawing skills I
have learned over the years have been,
to me anyway, in service to being
better able to expand my repertoire
of storytelling images. So if I can draw
better facial expressions then I can get
more emotion in the characters.
If I understand anatomy better then
I can make the figure do more
interesting things and make it more
convincing when it does them. If I learn
to draw better landscapes then I can
make the environments more believable
and more interesting. If I get better
at lighting, then I'm better at moods,
and so on. All of these combinations of
things and my skills as an illustrator are
all in service to the story, and can only
be done by practising.

*Practise makes perfect if you want
to improve your drawing skills.*

Tools and materials

You can have all the fancy drawing equipment in the world, but it won't make you a great artist. Invest only in the tools that you need and don't fall for the trick of thinking that the most expensive is the best and will magically enable you to draw like a pro. Sample your tools and materials until you find the ones that feel most comfortable, because that it was really matters.

The mechanics

These come in a variety of weights and thicknesses, and that's before you've even thought about the lead. You may be spending hours at your drawing board so comfort has to be your biggest deciding factor. All I really need to get started is any old pencil, a coloured pencil (blue, ideally), an eraser of some description and lots of paper. But remember, what works for me won't necessarily work for anyone else.

Choice

There is a dizzying number of drawing tools available to an artist. My advice is just to hone your style and choose the ones that work best with that, and that you feel happy with. Some people like to use mechanical pencils only and swap the leads out when they want a different softness. Others will have boxes and boxes of traditional wooden pencils that they go thorugh as quickly as I do rough paper. There are no rights or wrongs – find what works best for you. I tend to use traditional pencils for my rough work, and then move onto mechanical pencils when I need a finer point, or I'm picking out the detail in a drawing either on the lightbox or the board.

Shading

Different pencil softness is useful when you're shading, and using the side of a long, exposed lead is often the most effective way of covering a large area of tone. Have a go with a variety of pencils at different sharpnesses and just play around with the kind of tone that you can achieve and, more importantly, work out which is the quickest and most effective.

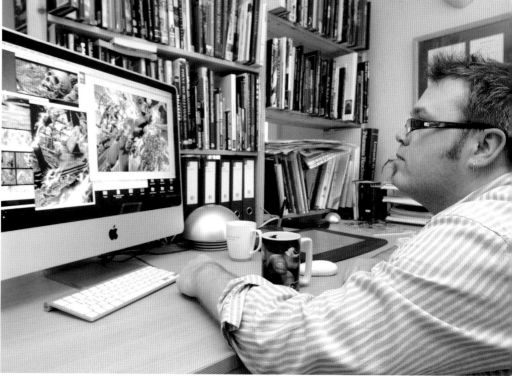

The hardware

Although you don't absolutely need to have a computer before you can get started, there certainly will come a point when you have to get one. Just make sure it's got a good, clear screen that shows your colours accurately, that you've got a colouring software package on there such as Photoshop, and that you have a flatbed scanner to copy your work.

The drawing process

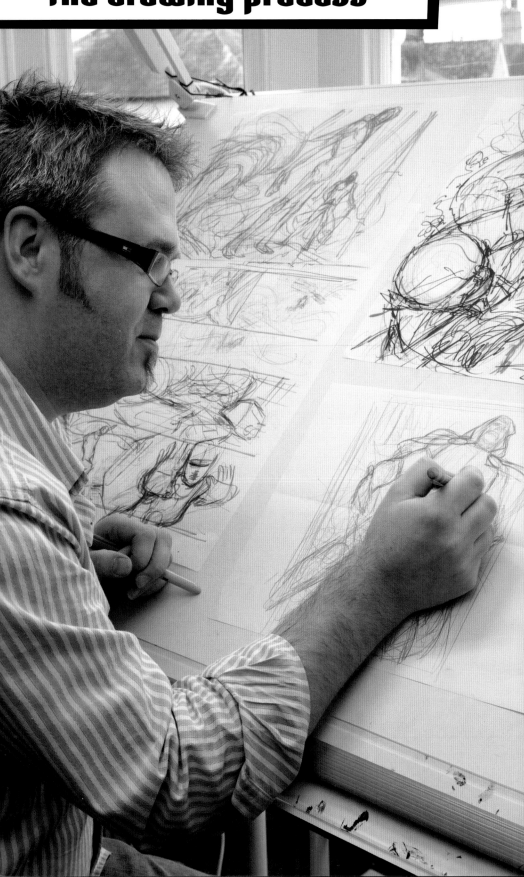

You've received and read your script, doodled all over it and have already started to visualize the story. You should have a clear idea in your mind of what you want each panel to look like, and now is the time to put it on to paper and check that it works.

The drawing stage

This is the first opportunity for you to really check that what you see in your mind as you read the script actually works on paper. It is a process for addressing compositional problems, not storytelling ones, so it's vital that you already have a clear idea of what you want characters and environments to look like. This might occasionally change as you find that a scene just isn't working, but the more you practise and grow in confidence the less this will happen.

The sketching process

It is a good idea to use a few different colours in your roughs to help you spot shapes and lines as you work. I use an HB pencil initially, followed by an erasable blue pencil and then red, black and blue brush pens.

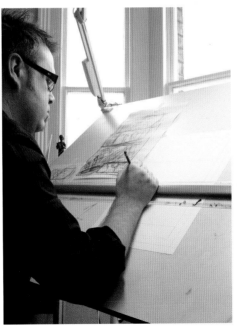

Ruling up

Your drawings will already have been ordered and sized with the panels in mind, so inserting the frame lines should just be a formality.

You will need to use rulers to measure up your panels and ensure that the space between each frame is correct.

Your rough sketches

These should be a full size version of the finished page, with your composition already having taken account of the rhythm of the story, the pacing and the sequential action that you planned earlier.

Work loosely and freely to get natural strokes and lines onto the page, and to allow your imagination to run wild. Trying to censor yourself at this stage will limit your creativity, so really let yourself go and come back with different coloured pens to pick out the best lines and shapes from the piece. Create as many roughs as you want to, until you're happy with the composition and have found some outlines that you feel work and that you're happy to take forward.

Vanishing points and panel frames are essential parts of the drawing process. I tend to introduce them at the stage after roughs, when I'm developing the piece, rather than do them religiously on all my roughs. Having said that, I sometimes find that vanishing lines

...the drawing process

are handy for helping me solve compositional problems and work out the best camera angles when I just can't seem to get it looking right. To mark vanishing points and panel frames I use erasable blue pencil; you can draw over it quite easily, and it just fades into the background once you add black or grey pencil, enabling you to see the composition, lines and shapes much more clearly. It also doesn't show up on scans, and gradually gets lost as you progress with your piece.

Down to business

Ruling up is a vital part of the drawing process for a comic artist. You don't need any fancy equipment to rule up your frame panels – an art board is useful, but not essential. The most important thing is that you don't work flat, and are in a position where you can eye up the panels easily.

A lightbox is a useful tool for the comic artist, as it enables you to create a more finished outline drawing while still keeping the rough. While this means that you can return for a second pass should you not be happy with the final drawing, it is a good discipline to know when something works and have the confidence to stick with it. Even if you think of another way of composing a scene or working an effect, leave it for the next piece, rather than going back and re-working an existing one.

Don't put too much time or polish into your drawings at this stage. Work quickly, lightly and instinctively. Switch the light off every now and then to check that the lines are making sense, and also to prevent your hands from getting too hot. And remember to stick both sheets of paper to the box with masking tape – there's nothing more annoying than realigning the pages when they keep slipping.

Try not to let the lightbox stage just become a tracing exercise – use the opportunity to refine or change things altogether, but the main thing is to come off the lightbox with a clean drawing that you can work with, and are happy with. Ultimately this will then go on to be inked, so the clearer the better!

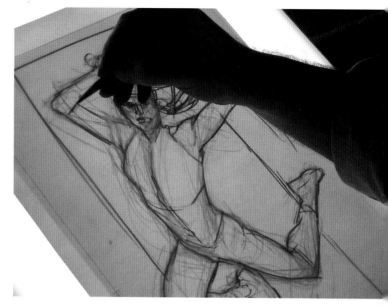

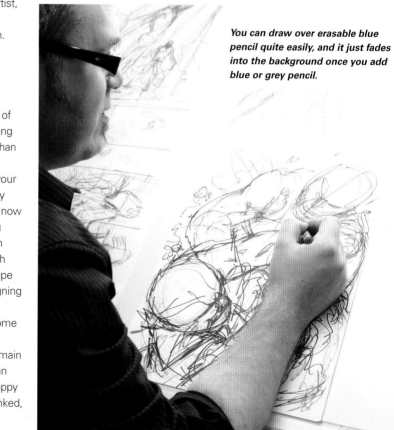

You can draw over erasable blue pencil quite easily, and it just fades into the background once you add blue or grey pencil.

On the lightbox

Try not to let the lightbox stage become a mechanical process of tracing. Do basic outlines on the box and then finish up away from it, adding more detail and tone. Have a clear idea of the point at which you're going to come off the box, and stick to it.

Picking the outlines

An ordinary 2H mechanical pencil is ideal for the initial outline work, providing the accuracy and detail that you need at this stage.

Mark making

The marks that you make are driven by several factors – the texture that you want to create, the amount of detail required, how much paper you need to cover, and movement, to name a few. You will figure out the most effective way of making your own marks, but the biggest factor behind the ones you choose has to be time: you can't afford to spend hours neatly shading in an area that's simply going to be coloured black by your inker.

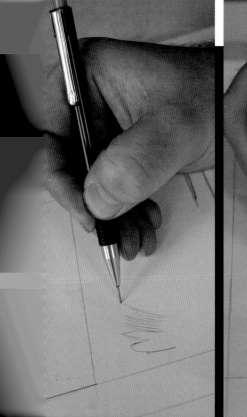

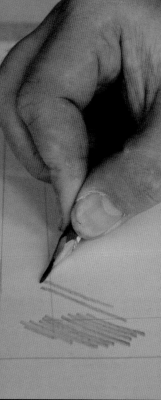

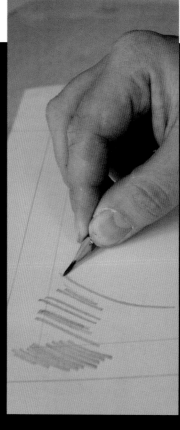

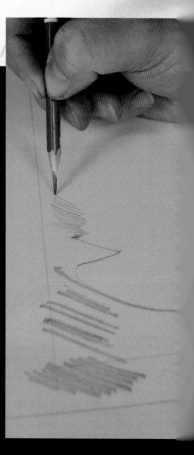

Mechanical pencil

This is a fairly basic drawing tool but very inorganic. You can scribble, sketch or draw finished drawings with it, but you have to outline every shape or every black that you want to fill in because the line is so precise. I tend to use a 0.9mm 2H lead, but you can experiment with the different

Traditional pencil

Using a traditional pencil enables you to shade large black areas without outlining (you can use an outline marked with an 'x' for this). This is a much more organic drawing and sketching process than with a mechanical pencil. I find that the best results combine both the mechanical pencil and a

Side strokes

Using the side of the pencil is the more versatile tool, but it really is a matter of personal choice. Some artists prefer to be precise and mechanical in their lines, rather than loose and organic. You need to find what works best for you.

Knife-sharpened traditional

Sharpening your pencil with a knife gives you a flat edge and longer exposed lead to work with, creating more variety in line density and texture of the mark. A traditional sharpener gives you a short point that gets worn down quickly. Use a mechanical or point-sharpened pencil when you want

To the point

The best way of getting a long, thick lead exposed on your pencil is by using a craft knife. A knife gives you more options to play with, and finishing the point with some glasspaper is ideal to get the length and shape you want. Always push the knife away from you when sharpening, obviously!

Keep it all to hand

As with everything in your workspace make sure that your drawing tools are close to hand – you don't want to be in the flow of creating your next panel only to discover that you can't find the pencil you need for the details. I tend to keep them all in my left hand so that I can interchange frequently and quickly. Erasers are handy, but I try not to use them too much. By the time I'm at the finished pencils stage all I should need to erase are the odd lines here and there that aren't quite right. Other than that I'm working in roughs, and will go over it with the lines that I want and will then pick those out on the lightbox later.

Never erase the panels you're not happy with because they are likely to come in handy later. You have to draw things so many times in this business that, if you think of a new way of doing things or find a new angle that isn't quite right this time, do not rub it out as you will undoubtedly find a future scenario in which you can use it.

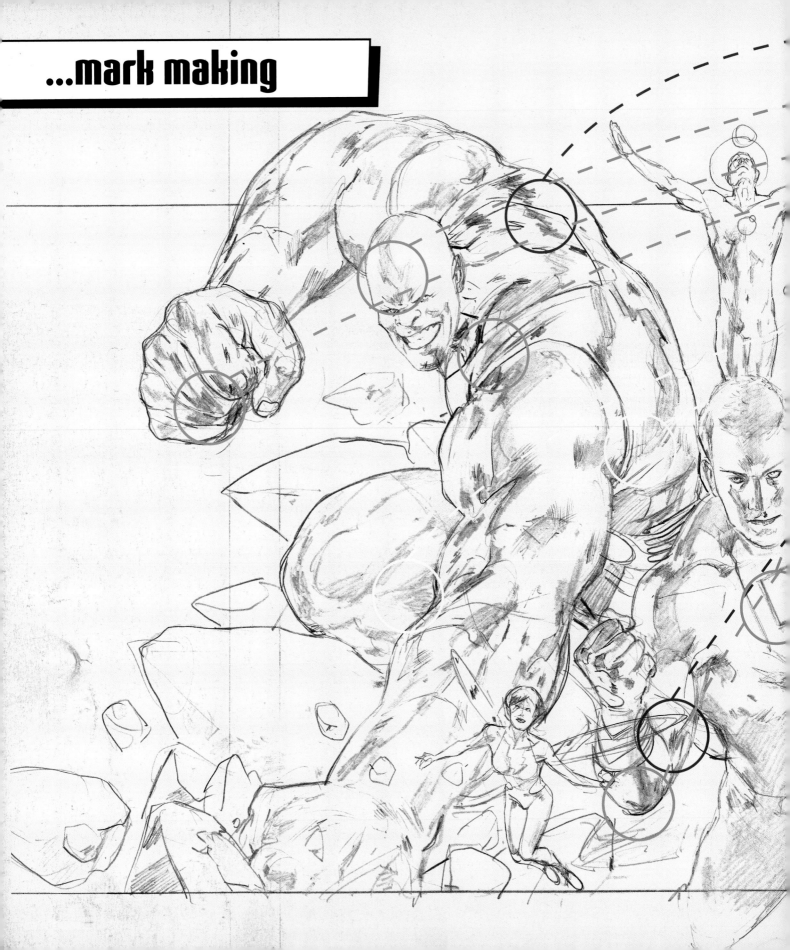

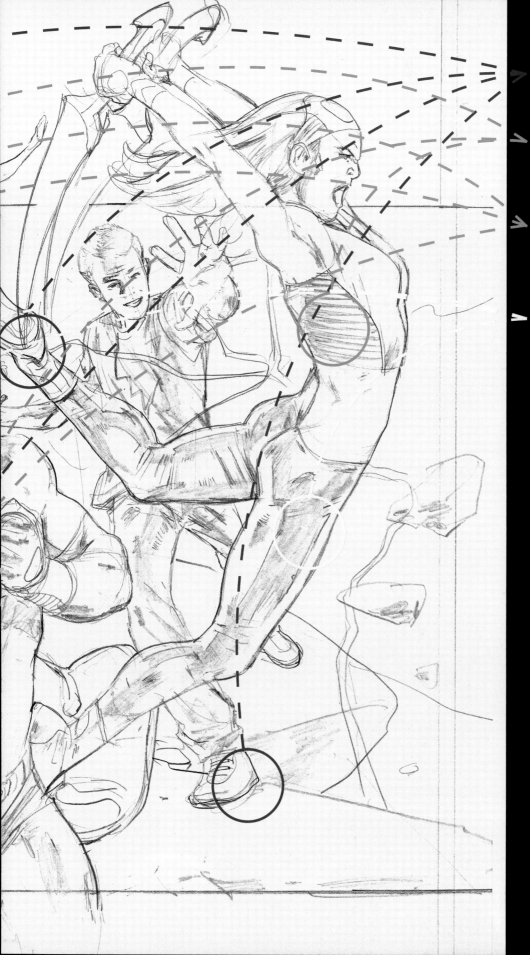

Mechanical pencil
Use it for the fine outlines and precise, detail work. You can't use it for shading large areas, though.

Traditional pencil
Softer lines and more fluid motion come with this tool. You can use it for detail, shading or general sketching, as the line it produces is very natural and organic.

Side strokes
Excellent for adding shading and tone. Covers an area quickly and adds nice texture, with a variety of densities.

Knife-sharpened traditional
The best tool of all. The long lead with the flat edge created by the sharpening provides you with a drawing tool that can produce a variety of marks, and can be used for both detail, shading and general sketching.

figure drawing basics

We're dealing with storytelling, rather than pin-up art, and this requires you to draw lots of figures in panels. It is vital, as a comic artist, that you are able to draw anybody doing anything. This doesn't just mean figures in heroic action poses – you have to be able to draw everyday figures doing everyday things.

Weight
Think about your pose and think about where the weight is going to be concentrated. You need to demonstrate this by the position and shape of the load-bearing area, be it the hands, legs or feet.

Figures at rest

As ever, your figures need to be a storytelling tool and enhance the story itself. The figures need to express the dialogue of the story, or be able to act the dialogue through body language and facial expressions. The most powerful figure that you need to be able to draw is the figure at rest, in an everyday, normal pose, as these are what sell the realism of the story and convince your reader to believe what you're telling them.

Weight

Be careful not to make your characters look like cardboard cut-outs – they have to be living, breathing people. Getting the weight of your character wrong creates a stiffness, which will be the first thing the reader will see as they try to figure out exactly what's going on.

Angles

These have to be spot on. The angle people hold their heads at when under threat, for example, can tell so much of your story. You don't even have to see another person here, but you know that this character is under attack. Think how powerful that could be as a storytelling device.

Leaping

Don't just make your character leap aimlessly about, as this will lessen the impact. Make sure that leaping characters have a real sense of direction and movement, and that you have worked out the perspective correctly.

Standing

Make sure that you convey the weight of a character properly. Not just their physical body weight, but the weight of something they're holding, or the tension or flex in the muscles created by the way that they're standing.

Mobile phone

Watch people with their phones and really study how they use them. How do they hold the phone? How do they look at it? What fingers do they use to press the buttons? Of course everyone has a different way of doing things, but the more options you have in your armoury the better.

...figure drawing basics

Essential skills

It is vital that you have mastered the art of figure drawing or, if you're only human like the rest of us, that you keep practising as much as you can. There are plenty of books available that explore the human figure and provide reference files for various poses, and these can be really useful. The best way of all, however, is to observe people and the way they do things. Really watch people carefully and check for the balance and weight in various parts of the body as they go about whatever they're doing. Do rough sketches if you can, or start to build up your own catalogue of reference images of various willing friends doing a variety of poses. And remember, it's handy to have reference for all of the flying, fighting, punching and action scenes, but most useful of all is the reference for everyday poses that we probably don't even notice or study most of the time.

Lines
The curvature of the body changes depending on what a figure is doing. You have to get these details right to be believed.

Observation
Watch people running, leaping, walking and really study how their limbs, muscles and joints work.

Lighting
This is a vital part of getting your character looking plausible. Choose an angle that enhances the storytelling.

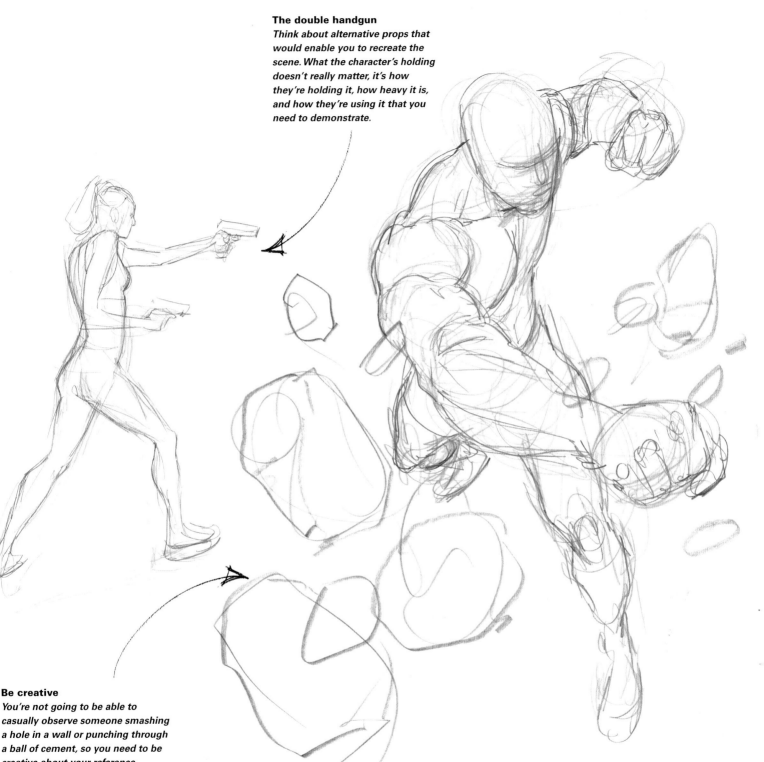

The double handgun
Think about alternative props that would enable you to recreate the scene. What the character's holding doesn't really matter, it's how they're holding it, how heavy it is, and how they're using it that you need to demonstrate.

Be creative
You're not going to be able to casually observe someone smashing a hole in a wall or punching through a ball of cement, so you need to be creative about your reference source. Study the various moves and stances that boxers use, for example, as this will demonstrate the weight distribution for you.

Drawing a figure

Having to draw a figure is an inevitable part of being a comic artist. You will be required to draw them from a variety of different angles, with a range of lighting, doing an assortment of different things, and all at different sizes and perspective.

Monkeys

Whether it's something you've made up from scratch or something that you've referenced, the starting point for sketching a figure is always the same – drawing. Don't try to trace a figure directly from a photograph because it never works – the proportion and perspective come out wrong, and it will end up looking like a monkey. Instead, do what the Greeks did with their statues and change the proportions slightly to make them real; lengthen the legs, shrink the head and lengthen arms slightly. There are certain proportion rules about how many heads fit into a human body. Exactly how many that is can vary from person to person, and I don't have any hard and fast rules. You have to do what looks right. Whether your character is tiny with narrow shoulders or over-sized and foreshortened, the muscles have to be in the right place and the head correctly positioned and angled.

Consistency

Whatever you use for your reference, the most important aspect to help you achieve believability is consistency. I don't have a mathematical rule to follow, I just know that if you draw a superhero to look like a real human figure it looks ridiculous. Whatever proportions you choose, it's the consistency that keeps people from realising that it doesn't actually look like real human proportions.

The process

Whether you're making something up from scratch or referencing a figure from a dedicated reference book or online, the way you begin the drawing is the same process.

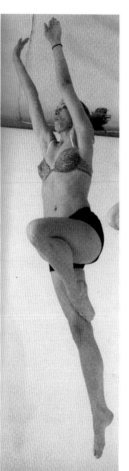

Reference
Don't try and trace a figure directly from a photograph, instead use it as a reference.

Blue scribble
All my drawings start with a whirlwind of blue pencil. I then use an HB pencil to pick out the lines and tighten the drawing up a little. It's still very loose and unpolished, though.

Cylinders
Some artists use cylinders to bulk out and add form to a drawing, but I don't personally do that – experience has enabled me to just start with an outline, but you must do what works for you.

Outline
Using a felt-tip pen I add in a stronger outline, and lines to indicate a costume.

Lighting
I have also started adding the suggestion of lighting by adding shade and tone. This helps the figure to start looking three-dimensional.

...drawing a figure

Lightbox
Happy with the previous drawing I then take it onto the lightbox to complete the basic full figure. This drawing is now quite tight with clean lines and form.

End point
If you didn't want to add any more detail, costume or lighting effects then this is a perfectly acceptable end to the drawing. For an image to be inked you simply need to have all of the basics in place.

Taking it further
If you do want to take it further then you need to add more lighting, both to increase the detail in form and the costume effect.

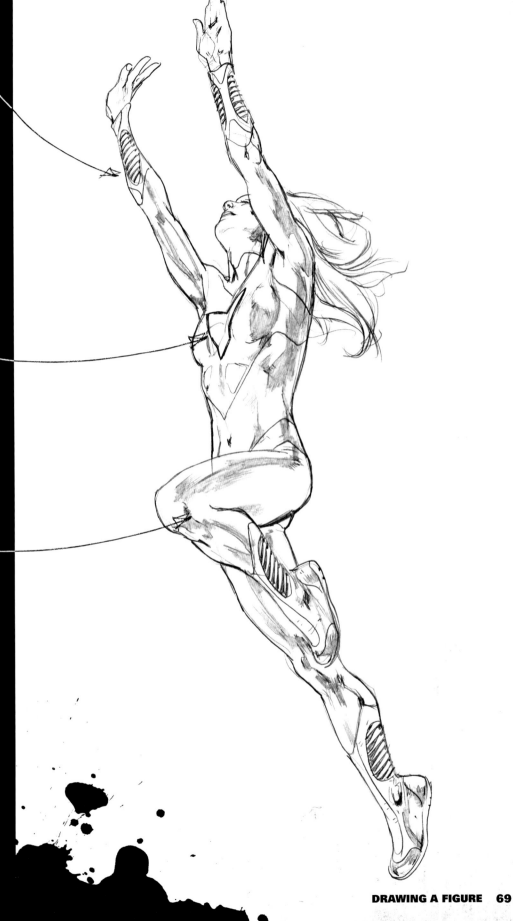

ack a step
ave gone back to the lighting stage to
d more detail to the image. Adding the
hting means that there is more form to
e figure.

ostume detail
get the metallic sheen of the costume
u have to add more light, because the
ht is what the sheen bounces off.

e flip side
dding more light means that you have
ore shadow, which enhances the three-
mensional properties of your figure.

e end point
u can work on a drawing for as long
s you want really. Just be disciplined
you're under time constraints, and
cognize when you're no longer actually
dding any value to the piece and stop. The
ain thing is that you are at a point where
e drawing instruction is clear for the
ker and can be followed to achieve the
ok that you want.

Expressive hands and faces

Face
Just because he's tense doesn't mean that he has to be grimacing. Tell the story using the lines of the body – taught muscles and a strong focused stare on the face.

At its most basic, the hands and the face are the things we use to communicate with. Close-ups don't have body language to help tell the story and the hands can work with the face to express an emotion.

It's obvious
The hands and face are the obvious form of expression in a person, especially when you don't have the full figure and body language to rely on. As a comic artist the most effective form of storytelling through characters

Tension
Clenched hands suggest tension and anger, but also a sense of resignation.

Emotion
The bars instantly tell you a story, but they don't tell you about the emotion of a situation. The characters have to do that.

Captain America *cover*

Having been falsely accused of being a traitor, Captain America has been forceful arrested and imprisoned.

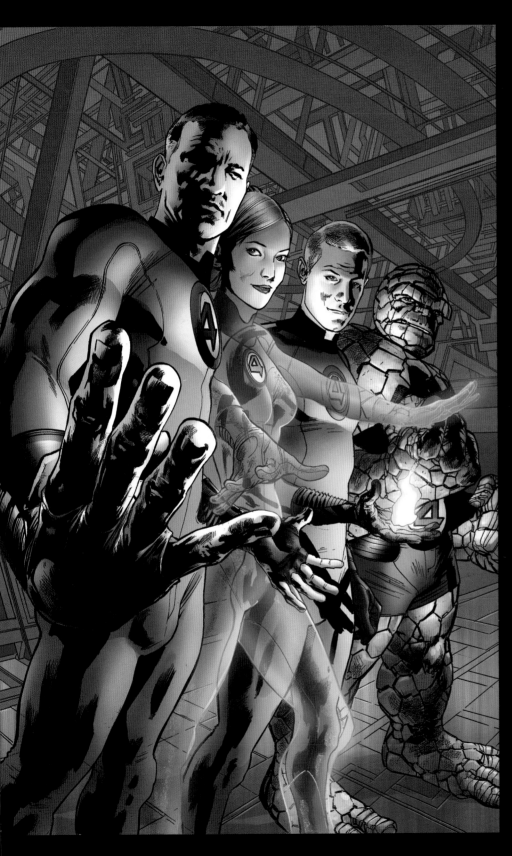

Fantastic Four **cover**

This was my first project with Mark Millar. I knew we needed a group shot for the cover as the first page of the story was an action one. I also knew that we wanted a more portrait-based first issue cover, which still had to scream '*Fantastic Four*'.

Symbolic

Having Reed holding his hand out with four fingers up, reminiscent of a gang-like symbol, is a very strong opening statement and sets the scene – it's the first thing you see. The background pipe work also crosses over to reveal lots of fours. Reed's other hand is gesturing to the rest of the team almost by way of introduction.

Both of Sue's hands are extended to all of the group as the maternal figure, while also demonstrating her power of invisibility. It might have been more logical for Sue to have her arms around everyone, but then you wouldn't have seen them at all. Having them at the front not only enables us to see them and the gesture, but also provided me with the opportunity to demonstrate her powers of invisibility.

Johnny's one hand is outstretched to show his power and is holding the flame, and Ben has got his fist ball ready for action as the strong member of the group.

Telling the story

Each character's hands are doing something in this image, and each is telling a story. Not only do they tell you that they are the Fantastic Four, but also something about the characters themselves and the roles they each play within the group dynamic and the powers they possess.

...expressive hands and faces

Maximise the storytelling

Every aspect of your panel should tell the story, and one of the greatest assets within that are the hands and faces. So much information can be conveyed from a clenched fist, a grimacing face or a hand clutching something. As with all of your art it is essential that you can draw hands in a variety of positions, and that you have a broad repertoire of faces in your collection. Photographs are vital references and so is a mirror. Practise and experiment, because the job is never done – you will always have to draw them!

Foreshortening is a tricky but useful device for introducing movement into your work, as well as enhancing the story. Foreshortening is where the perspective of the viewer is closer to the action, hence an object appears larger than those in the background. A flying fist, for example, can have the force conveyed not just by the clenching of the hand, but by the sheer size of the hand in the foreground of the image seen in comparison to the rest of the composition as it flies out of the panel.

Faces, and especially the eyes, are universal focus points where the viewer's eye is drawn. Not only can you convey much of your story through them, more importantly you need to ensure that they perfectly match the action of the story and panel.

Foreshortening
Imagine the impact this would have if the fist and arm were at the same size perspective as the rest of the character. Foreshortening, particularly of limbs, introduces movement and dynamism to a piece.

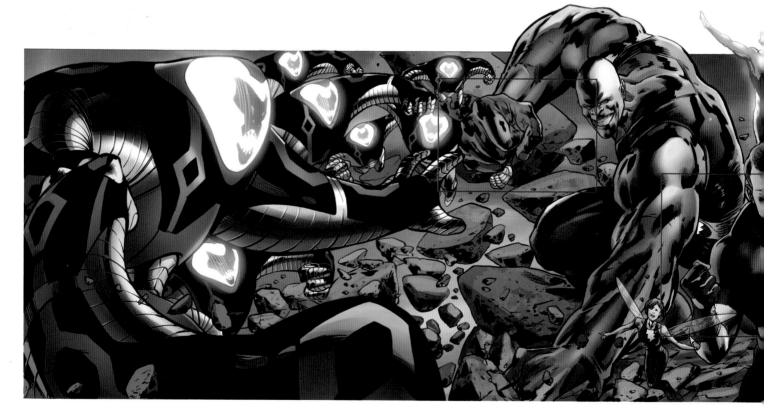

Busy hands
They should always be doing something. Make them active and use them as a tool.

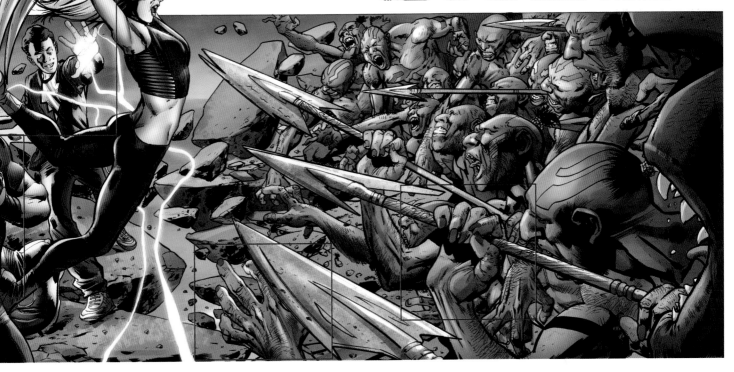

Joining the dots
It's important that the face conveys what the body is doing – a calm, smiling face here would have little impact and confuse the viewer about the story you're telling.

Character movement

The dynamic action figure is the staple of comic book art. Running, flying, leaping, punching, shooting, jumping. This is where you have to push the naturalism to the extreme. The key in these scenes is not necessarily realism, but power, weight and energy. Make it realistic and the power is limited to the everyday.

Introducing movement

You have to make your superhero action figures as realistic as your natural ones, and to do that effectively you definitely need to have mastered the concept of foreshortening.

Of course, you can just add in speedlines and blur things around the character, but personally I think that's sometimes a lazy approach. I like to introduce movement by creating power in the image, playing with the camera angles and perspective. The key thing is that whatever action you have to demonstrate, you can do it from a variety of different angles and viewpoints. You can have all of the elements in a panel and looking perfect, but they're not going to work and be as impactful as you need them to be unless you have the right camera angle that really puts the reader in the thick of the action.

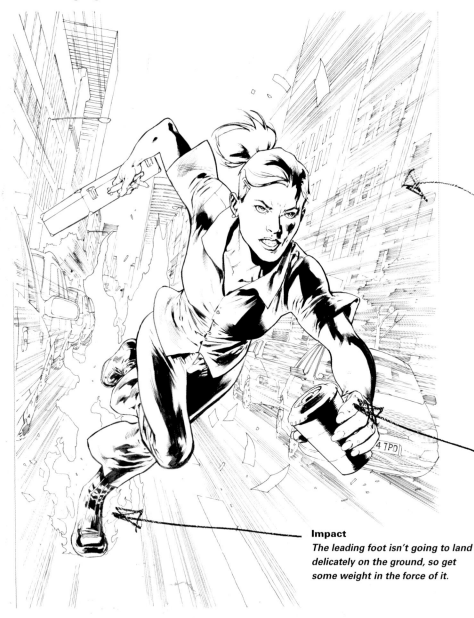

Stationary objects
These are excellent supporting characters, whether they're people, buildings or objects. Here the perspective tells you that the buildings are moving away from the figure, and the vanishing point makes you look beyond the character as if she's about to run past you. This is also a useful way to show what it is that your character's running from.

Foreshortening
The leading hand is larger than normal to demonstrate that it's closest to you as the figure comes storming towards you.

Impact
The leading foot isn't going to land delicately on the ground, so get some weight in the force of it.

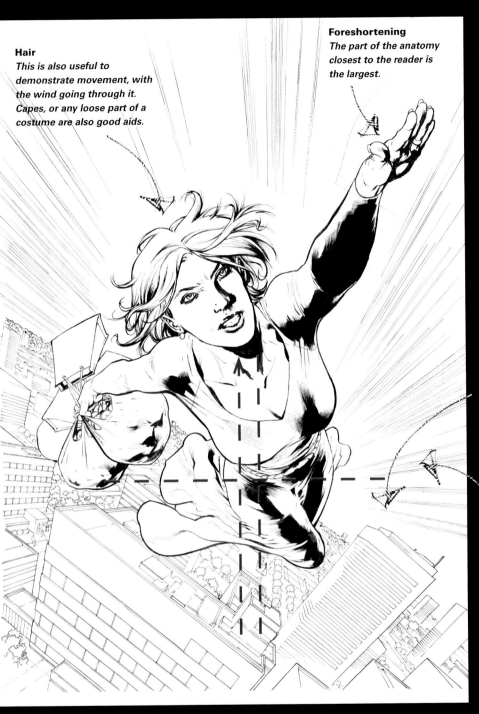

Hair
This is also useful to demonstrate movement, with the wind going through it. Capes, or any loose part of a costume are also good aids.

Foreshortening
The part of the anatomy closest to the reader is the largest.

Reference

All of the usual rules apply, of course, but if you want a reference shot of a person running like a superhero, don't use a shot of someone running because they invariably look static. Instead, get a shot of someone leaping, hurdling or speed skating, or doing something more extreme and powerful, requiring more of the human body.

Extreme sports

Always go to the extreme, as that is what you're after with this stuff. You have to show the power. You need to see how the muscles respond under that sort of duress, and how the lines of the body change according to what the character is doing. Studying this, and then getting it right, is the most effective way of introducing movement into your work.

Stationary objects
Once again the buildings are tapering away from the character. with the vanishing point leading your eye behind her.

Camera angle
Flying shots are always effective when shown from below the figure, especially when the angle reveals an environment that they've just been through. Tilting the camera as I have here also helps to pull the reader into the image.

Deodorant advert

Both of these drawings were done for a deodorant advert campaign on posters and in magazines, which accompanied a TV campaign. The premise was that everyday mums were superheroes who needed to be kept dry by their deodorant, so had to show mums as superheroes going about doing everyday things, such as rushing to work with a coffee.

...character movement

Lighting

Another useful aid to introduce movement is lighting. Having your characters or objects lit from behind, in particular, introduces a sense of movement forward and away from something. Similarly, uplighting a flying figure, from the perspective beneath it, can also be a handy device. You can also use skin or metallic costumes to create a reflection of something beyond the character in the centre.

Working together

Drop in some visual clues for the reader. Have vapour trails or fire streaks leading the way; make sure that car headlights point in a certain direction, that your characters are looking the right way, that those around them are watching or running towards them at the right angle, and that all the other elements have as much movement and clues to the central movement as possible.

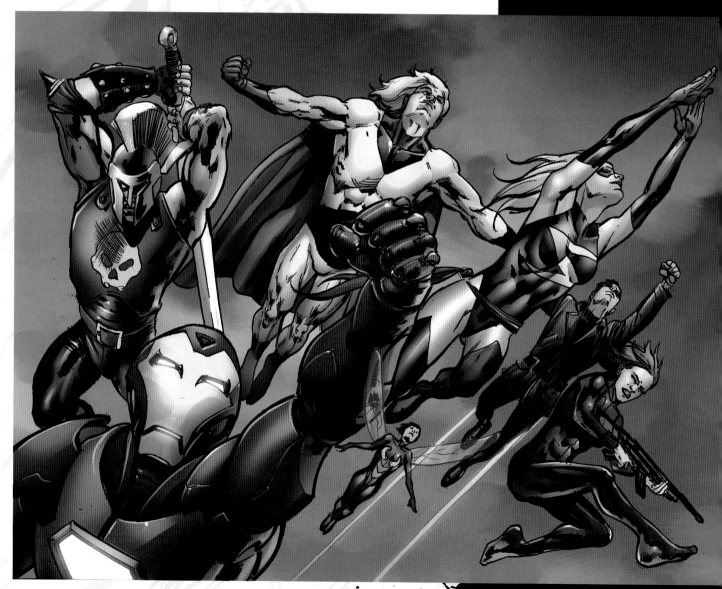

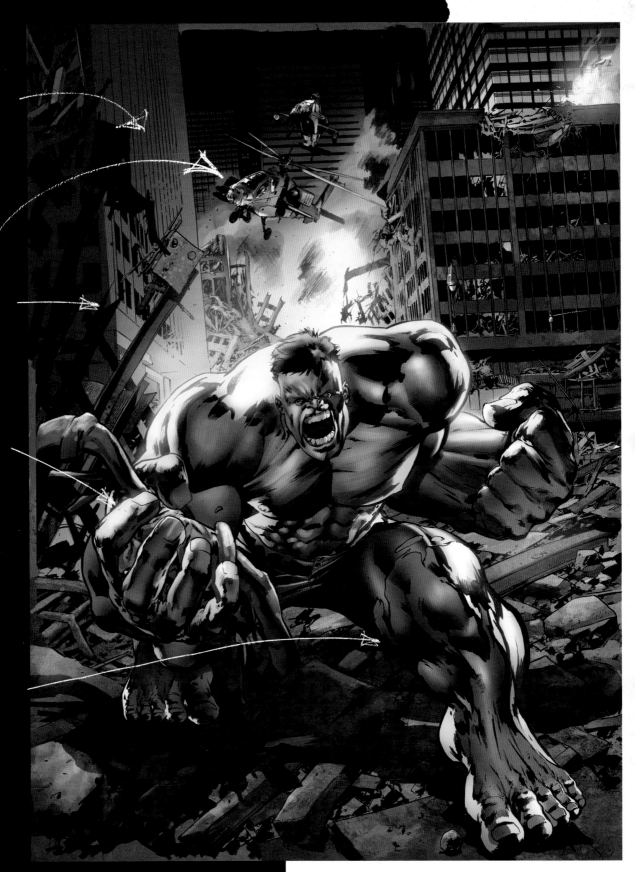

Lighting
The Hulk is lit from behind, leading the reader to believe that he's moving away from the action and fire towards you.

Pointing
A simple tilt of the helicopter suggests forward motion or a turn. It also makes you look at where it's going and straight into the action.

Static objects
The falling buildings behind point to the action, while the vanishing point is beyond The Hulk and leads your eye.

Foreshortening
Here, both the hands are foreshortened, along with the shoulders and fore leg. This demonstrates both power and movement, and his facial expression really makes you able to hear and feel him pounding towards you.

Muscles under tension
The muscles are taught and under pressure, especially in the leading leg which is what we see the most of it as he moves towards us. There would be no point having that level of detail on the rear leg, even if we could see it, because that would upset the weight balance of the image.

Character costumes

Contrary to what you might think, drawing costumes for comic books isn't all about skin-tight Lycra suits and intricate superhero armoured jackets. Because you are drawing a group of pre-defined characters that everyone is already familiar with, they have a wardrobe that is made up of both 'civvies' and their instantly-recognisable 'uniform'.

Choosing the outfits

More often than not you are actually told what the character has to wear, and that is all wrapped up with the fact that the characters are already known. The reader knows what they look like, and you have to be able to draw them over and over again so that the reader still instantly knows who they are. As such, you characters' wardrobe is going to be much the same as anyone in reality, except it will have a superhero costume in it as well.

If you are in the position to be able to design your superhero's costume then there are lots of things you need to consider, study and reference. The most important thing of all is to keep it simple. You can design the most intricate, detailed and fantastic costume, but are you going to be able to draw it exactly the same, from every single possible angle in every possible lighting scenario for panel after panel? Just remember how simple and iconic (and successful) Superman's costume was.

It's not just the clothes

No scene is a success just because of a result of the clothes the characters are wearing, or the way you've done their hair. It's all about how you make them act, and the clothes should be a secondary part of that – they shouldn't really stand out in a scene such as this one. What the reader is interested in is the story – where we are and who's present – rather than what you've decided to dress the characters in. Render the clothing badly, however, and it will be noticeable.

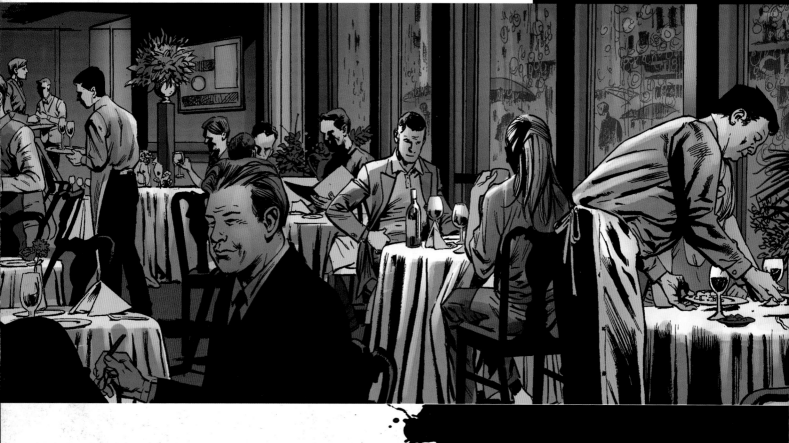

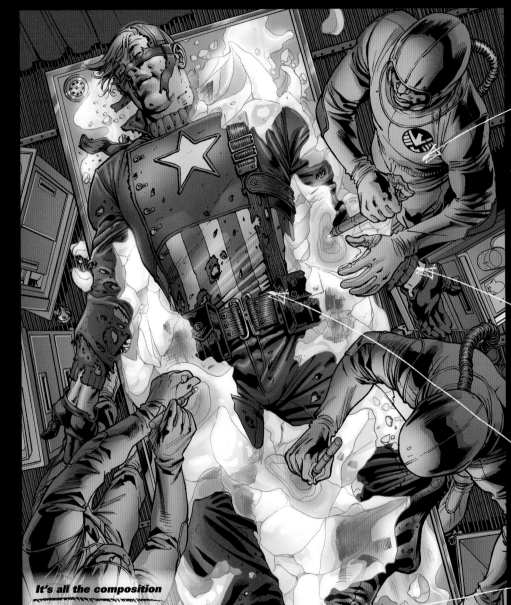

Getting it right

Whether your outfit is street- or superhero-wear, you need to render the fabric correctly. And by that I don't mean just the colour or sheen – you have to get the creases and folds correct, otherwise it will look like a sprayed-on outfit. I have found that the most important bit to get right is the seams of an outfit.

References

Obviously you can't go out and sketch your local superheroes as they go about their business, but there are certain things that you can research to help you with your costumes. Biker gear, wet suits and space suits are ideal references.

Lighting

Observe how different fabrics react to light, and how the fabric gathers up into shaded creases and folds. These little details are key to making your costumes believable and simply blending in as part of the story.

Footwear

I have a boot in my studio that I use just for referencing when I need to see what it might look like from a different angle, under a different stress, or simply to see how the leather bends and cracks and the light bounces off it. Do what works for you, but never be afraid to reach for that boot, because you have to get it right.

It's all the composition

Everything in the scene has to tell the story, as demonstrated here in The Ultimates, and no one part should stand out more than others. You will only achieve that by getting it right – a wrong perspective, rendering or factual inaccuracy will stand out and the reader will only notice that. Practise, practise!

Drawing environments

The location of your story is generally dictated by the script, but even then you have a lot of creative options open to you. But how do you find that perfect location and, more importantly, how do you get it onto paper?

Location

Marvel comics are generally set in real-life Manhattan, which means that the representation in the comic has to be recognizable and iconic. In other words, you have to draw the actual buildings in Manhattan, instead of some generic buildings with a sign outside saying 'you are in Manhattan'.

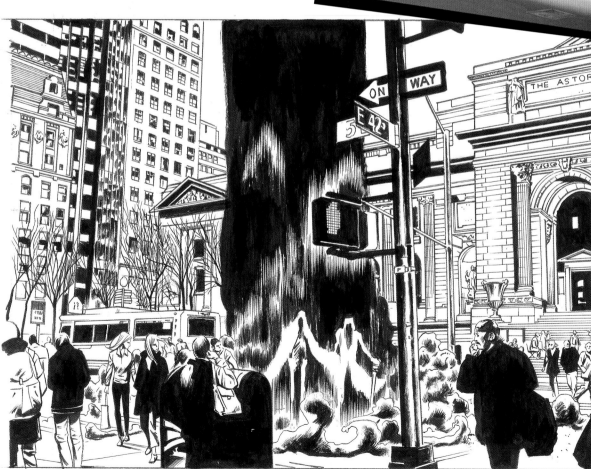

New York Public Library

I am fortunate in that I have a nice friend who works in Manhattan and will go out and take photographs of any particular area I want, from every possible angle. This is a great help and has enabled me to build up a reference file of images of the area. This shot is just around the corner from Marvel HQ, and although I used the reference photograph for some of the architecture, I then added people, traffic and two baddies arriving in a puff of evil-looking smoke.

How to do it

If you don't live in Manhattan then the best thing to do is to get hold of lots of books of photographs of the area. Although not ideal, at least this will give you material to get going with. They're not going to provide the perfect shot that you're looking for, so be prepared to hunt around for the ideal angle. The alternative is either to visit Manhattan yourself, or find a nice friend who is prepared to go out and shoot all of the street scenes you want.

The other options

If you're writing your own script or have free reign over the story's location then you have a number of options open to you. You can say that the story is based in New York or Chicago, but have the representation as fictitious. So you could base your story anywhere in the world, and then draw it to be however you want it. You could also make up your own location, such as Gotham City. Study buildings, lighting, weather, streets and the people and take as many photos as you can for your reference file. You can then come home and pick the street scenes yourself.

Wherever your story is based it has to be realistic. You will need to study different kinds of architecture and practise rendering them. Similarly, you will need to know how to draw cars, traffic and crowds of people. For your work to be a success it has to be believable, and it has to tell a good story and, in order to achieve that, you need to pay close attention to the little details and get those just right.

Artistic licence

This isn't actually the view that you see if you stand with your back to the New York Public Library, but it suited my shot for the next pane. Use your artistic licence and be creative with locations.

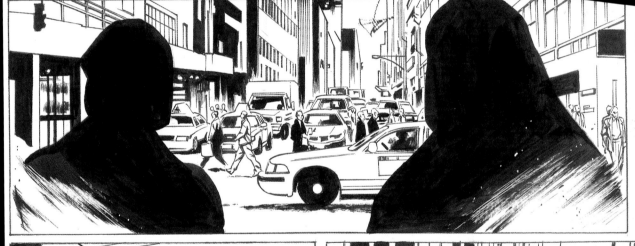

Icons

You're not going to be able to site every scene in a famous location. Include some sort of icon if you can, such as a yellow cab or a bus, so that the reader still has a good idea of where they are.

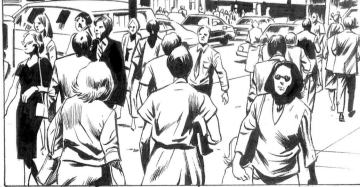

It's all about the imagination

Anyone can be given a script, research the location and find images of it to replicate and then get to work creating them in the story. You can have all of the reference shots in the world, but without a dose of imagination you can never make them fantastical or really suitable for your story.

Taking the next leap

Making the jump from drawing two engineers on a platform working on a helicopter tail to two men on a platform unloading a super robot onto an oil rig is down to one thing: your imagination. Applying your imagination is the really fun part of comic art – it's making the ordinary extraordinary. That to me is the real enjoyment of comic art. Whether you're writing your script yourself or illustrating someone else's writing, you're bringing the two worlds of fantasy and realism together, and that really unleashes your creativity.

Job description

As a comic artist you get to be an architect, a clothes designer and an engineer, among many other things. There are so many different creative elements to the job, and they are all impossible without a healthy dose of imagination. If you don't have that then you don't have the passion for the story.

Draw what's real

All of the hardware that you see in my work is a combination of imagination and tons of reference. I'm not a fan of making things up completely, and think that if you're creating something that's real you have to make it completely believable, otherwise the whole world might as well be complete fantasy. Much as I love fantasy and making things up, sometimes that just isn't the best way to tell a story, and you have to draw what's real.

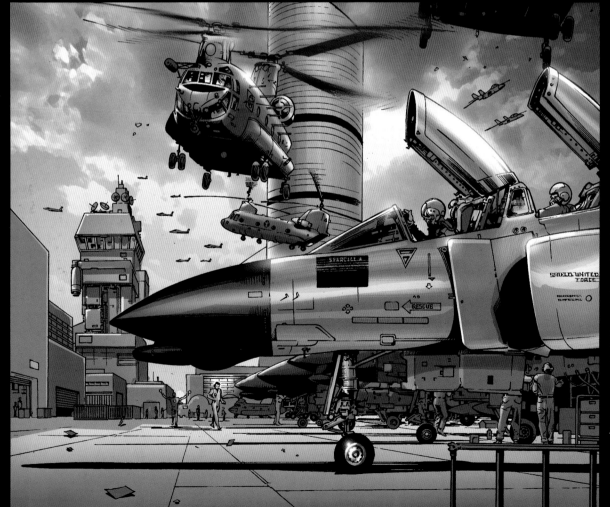

An establishing shot showing the action on the base of The Ultimates HQ Tiskelion, in Manhattan, as most of the other establishing shot had been aerial. Over the course of a comic you have to show the same thing so many times, that you have to find new and unusual ways of doing it when you can, and showing the action from here was just that.

Experience

Creating a drawing of the Manhattan skyline at night is straightforward enough. Find an image that has the angle and detail that you want, and pick up your pencil. Drop an evil Spiderman-type character into the middle of that and where are you going to get the reference for that?

The more you do something the better you get at it, so while I'm able now to just visualize what I want the scene to look like and then draw it as I see it, you might not be able to. So practise, and then practise some more. Get used to drawing all manner of characters in any kind of position, and really push your skills, rather than keeping on doing the same stuff. At the same time you will probably find that this really fires your imagination, and you will start thinking up and exploring lots of other possibilities with your work. Once you are confident and really in the zone then the possibilities really are endless.

Marvel New York

Ben is about to propose to his girlfriend and he's just brought her in the Fantasticar to a special place where you can see New York. The Fantasticar is facing right–left with Spiderman left–right, which means that Spiderman looks like he's moving, but the car doesn't. The night shot helps to pop Spiderman's suit, and is so obviously a New York-type city skyline at night. I find that having the fantastic back-dropped by the hyper-real often makes the fantastic even more awesome.

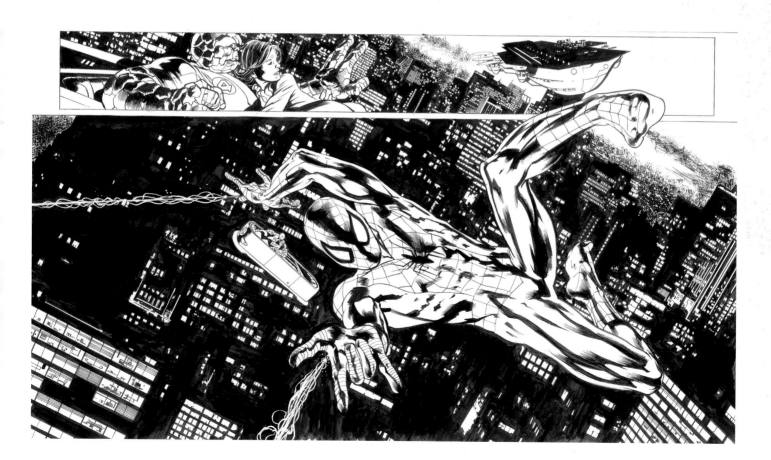

The hardware

You might not be able to find the exact reference for the type of hardware that you need to create, and that's where you have to use your imagination. Making sure that you get the important details right will often do the job, such as the correct uniform or livery. It is the minutiae in the detail that makes something really believable.

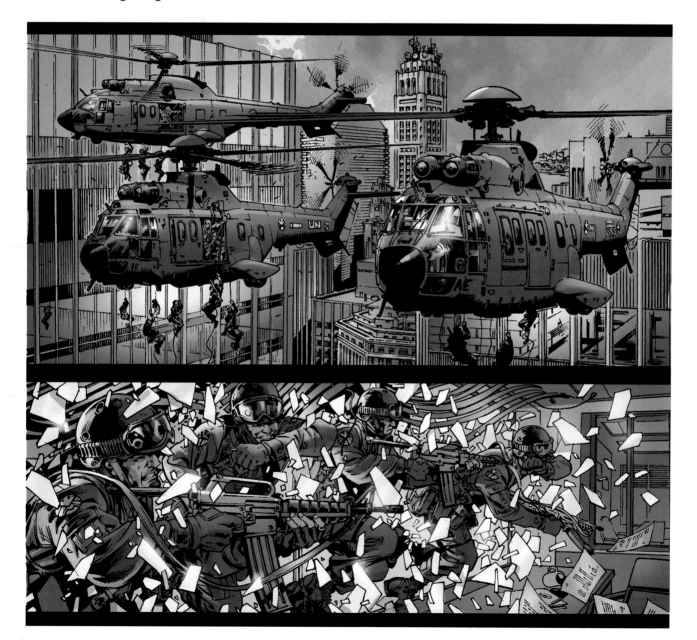

Getting lucky

Sometimes you get lucky and find an excellent reference source, such as I found in Russell Sheath. Russell was with the British military forces in Iraq and he took copies of *The Ultimates* out with him, as did a lot of the US soldiers. Russell got in touch as a fan, and has been a superb source of reference for me ever since, because he has all of this information at hand. I would give him a brief outline of the story I was working on, or what I particularly needed to illustrate and he would go and shoot it for me. He has become my unofficial military adviser.

Captain America cover

It was rare to see Captain America shooting a gun, and I knew that I wanted him to be shooting a large, super-heavy machine gun from a bunker, so I got in touch with Russell to find out what kind of gun I could source for reference. I told him the outline and the very next day he provided me with pictures of a suitable, US gun that Cap would use. I was able to get the exact shot and angle that I wanted just because he went and shot it for me. I sourced the uniform references for this series online. Even if you don't have your own private source of reference photos you can always go online – you will invariably find something that you can reference or use as the basis for something that you can then tailor.

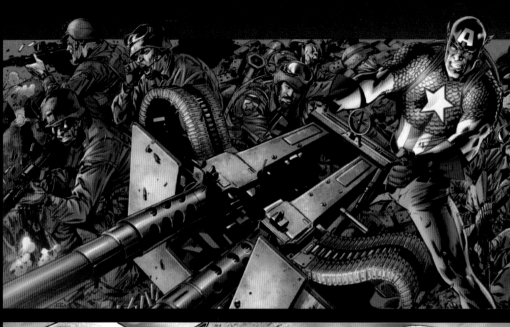

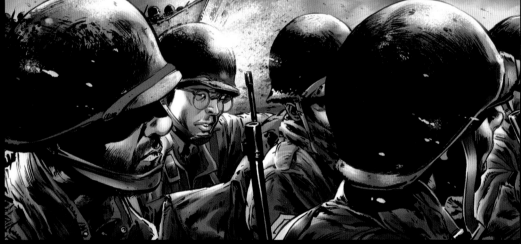

It could have been anything

I had limited reference for US military equipment, so I had to use these European ones, and thankfully no one has found me out yet! The background is a classic New York city shot and, combined with the helicopters and troops, makes a believable shot that gets across what it is I'm trying to convey. The background is so solid that I could have had anything added to the foreground, and the location would have stayed the same – you could even have had Ironman or Superman flying past and it would have still been New York.

...the hardware

Pearl Harbour

In this shot a huge explosion has gone off and taken out the massive fleet of aircraft carriers. The easiest reference for a similar event is World War II and Pearl Harbour (not the film!). I studied pictures from the event, and looked particularly at how the boats looked when they sank in the waters of a bay or harbour. I then went online to find real-life references for the towers and bridges of aircraft carriers in the US fleet. This image, like most, has a different combination of references – those for feeling, perspective and then the actual reference for the objects themselves, along with a good dose of imagination.

Ironman the fighter jet

I decided to do this cute little shot of Ironman flying with the fighter jets simply because it makes him look cool – he IS the fighter jet, whereas the other guys have to fly one. This provided a more interesting take on the formation than a groundshot would have done. This scene was actually brought to life in the very first Ironman movie!

I thought it was interesting to use the point of view of the pilot so that you get a really cool shot where Ironman looks like he's one of them.

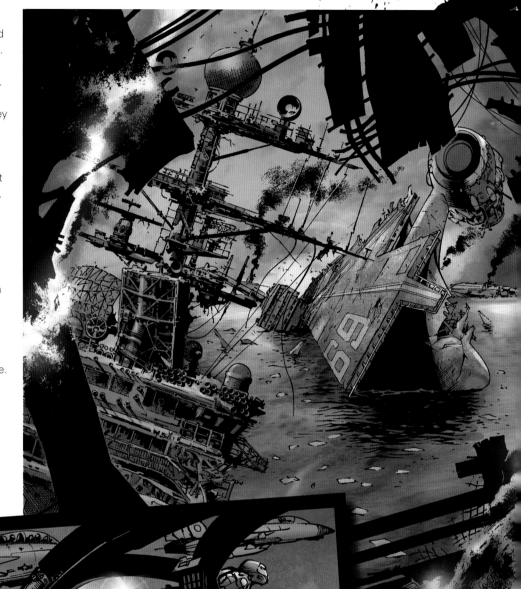

Out and about

For this steam train shot I went out with my camera and visited steam railway museums and heritage lines. Even if you can't do this you can always easily find reference images – the train doesn't even have to be moving in the shots, as you can make it look like it's moving when you come to render it.

Governor's Island

Just off the southern tip of Manhattan Island there are three small islands – Liberty Island, Ellis Island and Governor Island. The latter was the inspiration for the Triskelion, which was The Ultimate's military base. I took the basic shape of the island as my reference, and then created the HQ within it. If Triskelion was actually to scale it would spread from Brooklyn to New Jersey, but that doesn't matter. You don't have to actually create a spotter's guide, and nor does anyone have to go and visit the places you create – everyone knows it's in the bay off Manhattan Island and that's all that matters. You simply have to create locations that have realism and that enable you to tell the story.

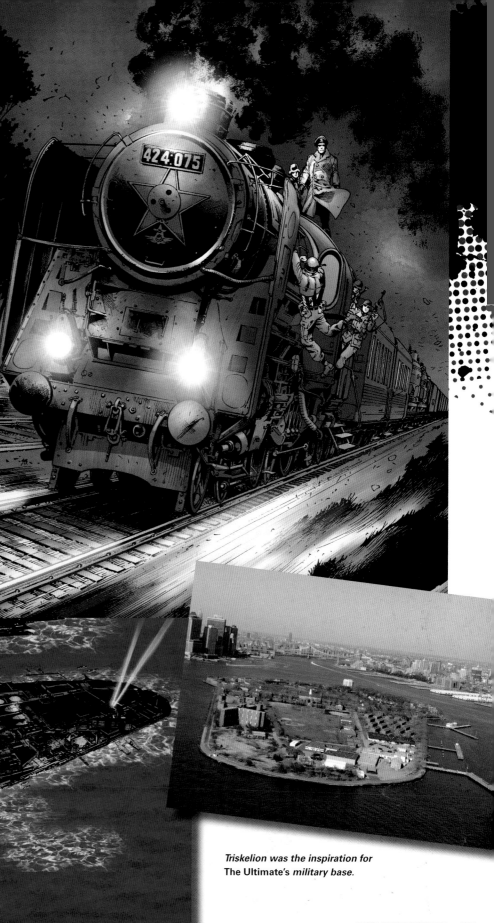

Triskelion was the inspiration for The Ultimate's *military base*.

Camera placement

Three of the fantastic four have been shrunk and injected into Johnny Storm's body, so Psycho Woman gets to be a towering, giant figure who requires a lot of power to fight. Ben's punch therefore has to have enormous power, and it was this power that needed to be established in the shot.

I start with my thumbnails to work out the composition of the panel. I knew that the camera angle was crucial here to get the power across, so I played with a few scenarios.

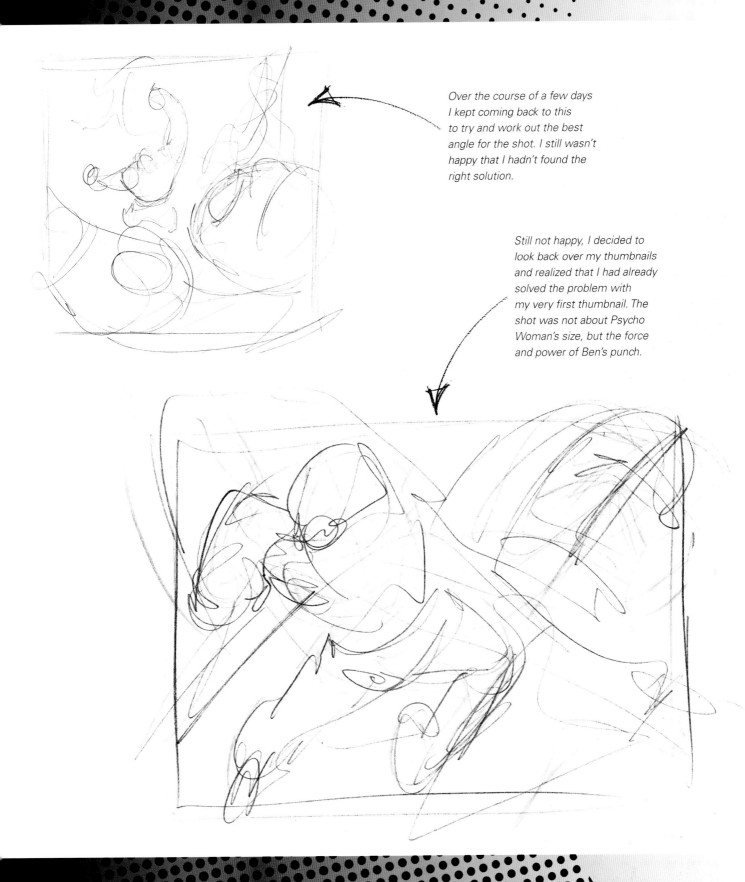

Over the course of a few days I kept coming back to this to try and work out the best angle for the shot. I still wasn't happy that I hadn't found the right solution.

Still not happy, I decided to look back over my thumbnails and realized that I had already solved the problem with my very first thumbnail. The shot was not about Psycho Woman's size, but the force and power of Ben's punch.

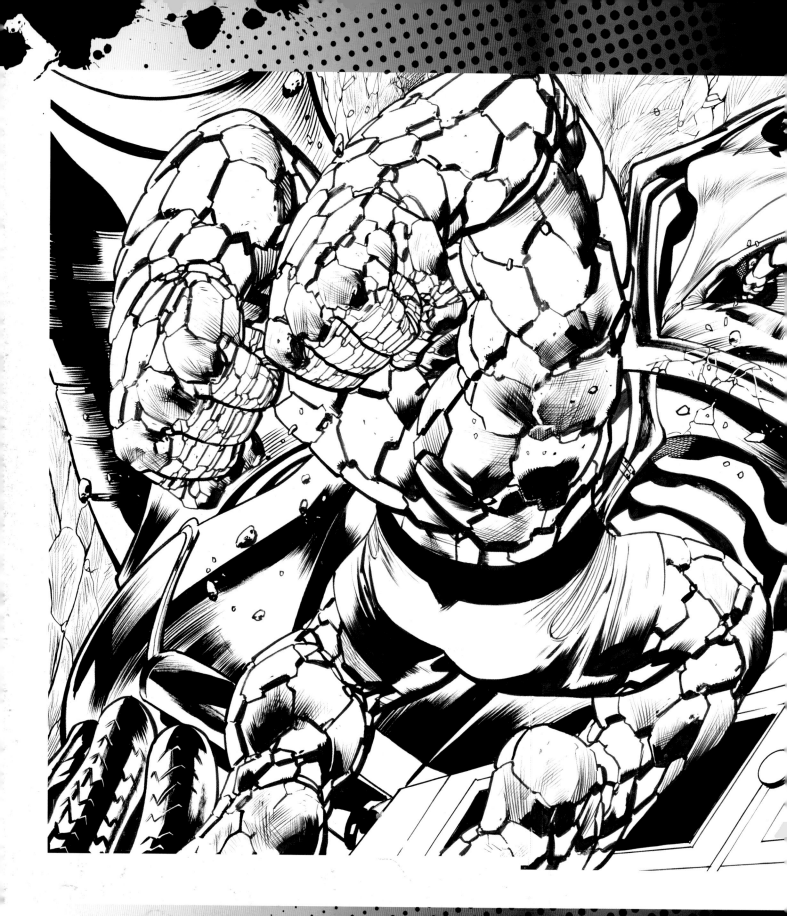

How to do it

I can't tell you how to get the power in the shot right. I can explain about the composition and making sure that the power is where you want it to be (in the punch, rather than the background). I can tell you that the camera angle is paramount, so that we get the angle and size of Psycho Woman's head. Having Ben with his back to us, both fists in the air and his head not visible also add to that. Beyond that it's so intrinsic and instinctive – I can't tell you how to be energetic.

Trust your instincts

I really struggled with this one until I was happy with with the angle and was sure that I had got it right. I always find it interesting that it was my very first idea that was the right one, and of course the one that I discounted. It was a really fun piece to do, and I enjoyed the challenge of finding the solution to the problem. The key elements are here, such as ensuring that you see the punch before the impact, and having all of the action in the figures rather than the environment also helps. Above all, it has taught me to always go back and see what my first instinctive reaction was, as it's often the best one.

The shot is about the force of the punch from Ben Grimm, alias The Thing, not Psycho Womans's size.

Inking & Colour

Born out of the New York sweat shops of the 1930s American comics have always been assembly line products. Due to the volume and speed of their production, comics were broken down into the various tasks of penciller, inker, letterer and colourist. Sometimes the pencilling was broken even further to layouts or breakdowns, then finishes and inks. This wasn't so true in Europe or Britain where the artist did his own inking and often the lettering and colouring too, but in the American market it set the precedent we mostly still follow today. The penciller reads the script and makes the choices about how the story is told. All the drawing is then done in pencil before the pages are sent to the inker to finish. The inker then works over the top of the pencilled pages using black ink and whichever tools are his preference, the usual being brushes, dip-pens and all variety of felt-tip pens.

The inkers contribution to the comic book process is vital, taking the rough pencil sketches and turning them into finished pieces of art.

Tools and materials

As you would expect, the tools available to the inker are myriad, and prices vary accordingly. Having the best pens won't make you the best inker. Go with what's comfortable – both for your hand and your wallet – and most importantly, get as much practise in as you can.

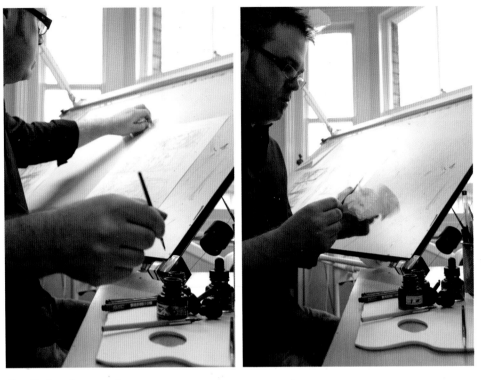

Comfort and convenience

Inking can be a messy business, so the last thing you want to be doing is hunting around for some paper towels when you've loaded too much ink onto the pen. Keep everything to hand and make sure that your workspace is properly set up with everything you need before you start.

If you're a brush inker then a smooth surface is ideal; if you're a pen inker then you'll want a smooth but hard surface.

Bare minimum

The basic tools any inker needs are dip pens, brushes and marker pens of varying thicknesses, a pot of ink, masking and correction fluid, a ruler, some water and lots of paper towels. The brushes that you buy will last you years, so choose carefully and make sure that they really fit your hand. If you look after your brushes and clean them thoroughly after each use, then they should last you a while as well. You will need the paper towels to absorb any excess ink from the pens and brushes, to wipe them clean, and to clear up any spillages.

Supports

If you're inking your own work then you will have made the decisions about paper at the pencilling stage, and if you're inking someone else's work then they will have made the decisions at the pencilling stage.

If you're predominantly a brush inker then you're going to want a smooth surface; if you're a pen inker then you'll want a smooth but hard surface because the pen will dig into the paper – you can't use a dip pen on watercolour paper, for instance. If you're using a rough surface for brush work then your marks will pick up the surface texture of the paper, so you need to go smoother. Most papers are now available in pads, so buy lots of different weights and surfaces and test the effects until you're happy with the marks you've made. You can also buy pre-sized comic art paper online, which is the same type that DC and Marvel use.

Your brief

It is rare for a professional comic artist to ink and colour their drawings, and setting up as an inker is an option open to you. To do this you will need a portfolio that demonstrates a wide range of skill and talent with the brush strokes, and a sensitivity in your interpretation of the original artist's instructions. These days, most pencillers will be providing very tight and clean pencil drawings, leaving the inker with little to do apart from effectively trace and finish the drawing for print. Even if this is the case you will still need to understand the intentions of the drawing – a simple, traced drawing will look lifeless and static.

A good inker must have some drawing ability and be a capable artist in their own right. The inker's role is to always try to maximise the artist's intentions, not overpower the lines with their own style of drawing. The best results come from a true partnership where the penciller is able to draw naturally and not have to try to 'ink' it at the pencil stage. In the longer-term partnerships a sort of short-hand develops between the penciller and the inker, with the penciller trusting the inker to interpret their lines. The difference between a good inker and a tracer is the difference between a writer and a typer.

Be tidy

There's always a pen that leaks, or an ink that's too thin and runs more than you want. Your hands are likely to get inky as well, so you need to be careful not to get smudges and finger marks on the artwork. Use something to lean on, such as a ruler or clean sheet of paper, and change to a new paper towel as soon as one gets dirty.

Make sure that you clean your brushes and pens as soon as you've finished with them – there's nothing more frustrating than coming to use them the next time to find that they've dried out.

It's a good idea to keep all of your inking tools together in one place, and definitely to store them apart from your drawing kit. Avoid doing your inking on your drawing board until you are confident that you won't make a mess of it – a wooden board, similar to the one I use for roughs is ideal.

Take your time

It takes a lot of time and practise to hone your inking skills. Use lots of rough paper when you're just starting out, and above all try not to rush – you might have a looming deadline, but you still need to take the time and care to do the job well.

Approaches

Several years ago, an inker (who shall remain nameless) asked me what pen I used when I was inking. So I told him, and he said that he'd never tried those particular ones before and asked where he could buy them. Unfortunately these pens were no longer made.

I told him about a special little shop in London that still sold inking tools from decades ago, and if he went round there then he could get a couple. He took note of where the shop was, but I had to warn him that this shop only appeared every other Thursday, and was in a different location each time. The inker was fascinated by this little magic corner shop.

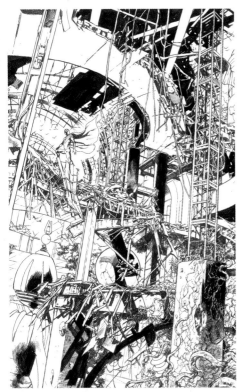

Focus on the detail

The detail in a piece has to be meticulously described by the inker. Pencilling the detail can be time consuming, but it takes longer for an inker to get those final marks down.

There is no magic

The reason I'm telling you this is because this particular inker was always looking for that magic tool that would enable him to ink like the people he admired, so he wanted to replicate exactly what they used in order to recreate those techniques. I've been down this road myself, and you probably will do at some point as well, but you have to realize that you can pick up exactly the same tools that the inkers you admire have at their disposal, but no one in a million years will be able to replicate exactly what they do with them.

Unique inking

Inking is like handwriting – you can use exactly the same fountain pen as the next person, but the writing would be incredibly different and unique.

Inking is different from pencilling because it really is a skill, as well as an artistic medium and interpretation. The pencil can provide different tones and densities according to how you use it and how hard you press, but you can't do that with ink. You need to find a way with the solid black ink to get that softness and difference in tone by varying the density of your rendering, and that takes skill and experience, and it is this that makes the good inkers stand out, and means that you trust them with your work. An ink line is either there or it isn't, and you need to be confident that whoever inks your work will apply this sensitivity and skill that you're looking for when tackling your work because it's impossible to undo the work once it's done. Similarly you need to be able to achieve the

Each person holds the pen differently and uses different strokes, hand gestures and arm movements to achieve the same marks.

same level of diversity in order to do justice to your own work when you take it into inks.

Picture it

I can pick up virtually any implement and recreate the inking lines that I need, because I have a clear picture in my mind of what the end result needs to look like. The tool itself is almost irrelevant. So use whatever you want to do your inking, making sure that you're comfortable with the implement, and learn to work with the strokes and marks that are unique to you – they are no better and no worse than anyone else's. Know exactly what it is that you want to achieve and what it looks like, and you will be able to do it even if you're using the blunt end of a stick.

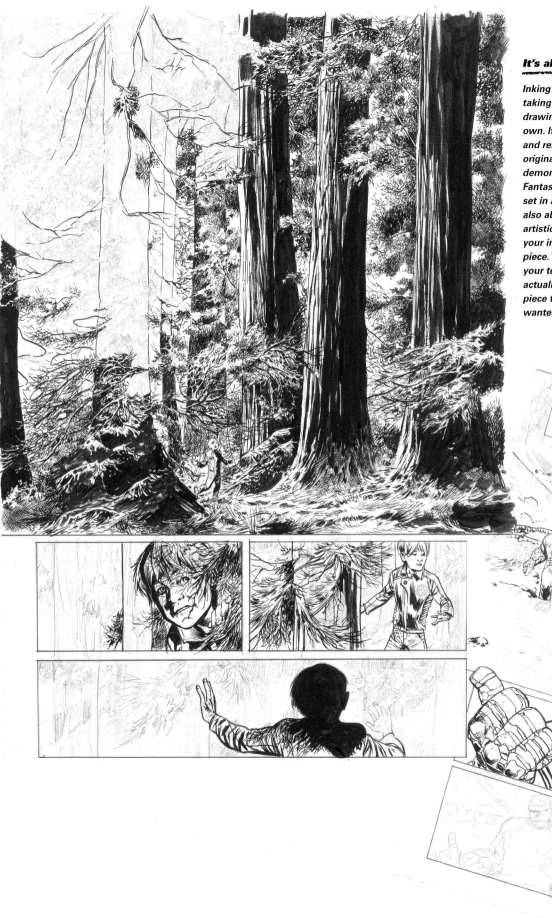

It's all in the skill

Inking isn't about tracing, or taking someone else's pencil drawing and making it your own. It's about being aware of and respectful about the original artist's intentions, as demonstrated here in the Fantastic Four Christmas story, set in a Scottish fairytale. It's also about making your own artistic judgements based on your interpretation of the piece. The skill is then honing your technique to be able to actually deliver a strong, inked piece that is just how the artist wanted it to be.

Techniques

Inking is not about the tools, it's about the mark. Use any dip pen, brush or marker that you feel most comfortable with, and that you feel most matches your style. You need to have fluidity in your arm movements and relative flexibility in your grip otherwise your lines will be too tight and unnatural. Try to draw the strokes from your elbow, rather than your wrist.

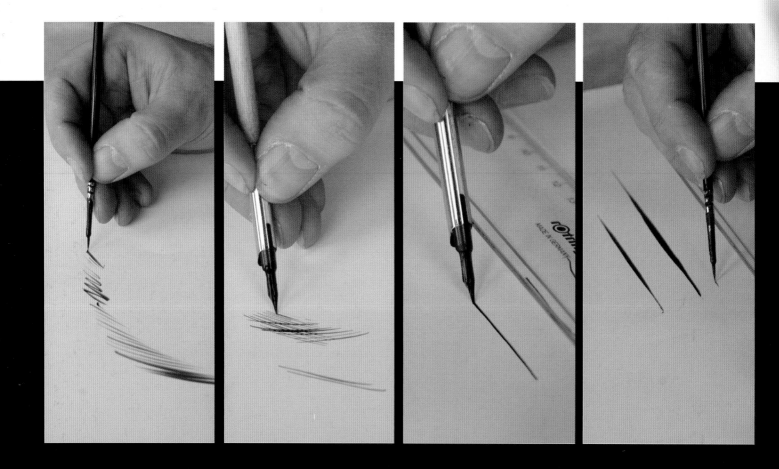

Feathering

Brush strokes, often known as feathering. You need lots of natural movements either from the wrist or the elbow, and this stroke is used for general free-hand mark making. I'm using a size '0' sable brush. Sable brushes provide a wider range of sensitive marks than the synthetic brushes, but are softer and harder to use.

Hatching and cross hatching

More free-hand pen work. Hatching is when you create a variety of parallel lines, which are crossed in the other direction to produce a grid, which is cross hatching. This results in a grey rather than a solid black, and is useful for areas of tone and shade, or where you just want a bit less density. I'm using a Jillott 1960 dip pen.

Pen ruling

You can do these lines with a mechanical or felt-tip pen, but using a dip pen will enable you to vary the thickness of the line according to how much pressure you apply. Tilt the ruler upwards so that it rests against the shaft of the pen holder, rather than the nib. This stops the ink from seeping under the ruler and spreading.

Brush ruling

This is the same principle as pen ruling, but produces a much more versatile and organic line. Again, tilt the ruler above the brush area of the pen, not just to stop the ink seeping but because the brush is very soft and sensitive, and you don't want the ruler interfering and affecting the line your trying to make.

Comfort

Walt Simonson is an artist who I have admired
for many years, and who nearly always inked
his own work using a Hunt 102 Pro-quill pen.
He literally used to gouge holes out of the
paper. I met up with him a few years ago and
he was eagerly showing me his new work.
He had started using a brush, and couldn't
I tell the difference? Even a seasoned pro
couldn't have told the difference in the brush
marks, and the end result was as typically
good and powerful as his other work. He
was still making exactly the same mark, even
though he was using the polar opposite of the
tool he used before.

 The moral of that story is to choose the tool
that you like using the most, and work with
that. I use a variety – some people only use
one type. The choice is entirely yours. What
matters is how you're going to use that tool.

All part of the plan

The marks that you deploy are dictated by the
piece that you're working on. Inking a solid
area of black, for example, is going to require a
different technique to picking out the detail in
a superhero's costume. How you work around
the image is as much about personal choice
as logic – some people like to begin by picking
out details, while others simply work their way
around the piece methodically. Make sure that
you stop quite often to assess the way the
image is going.

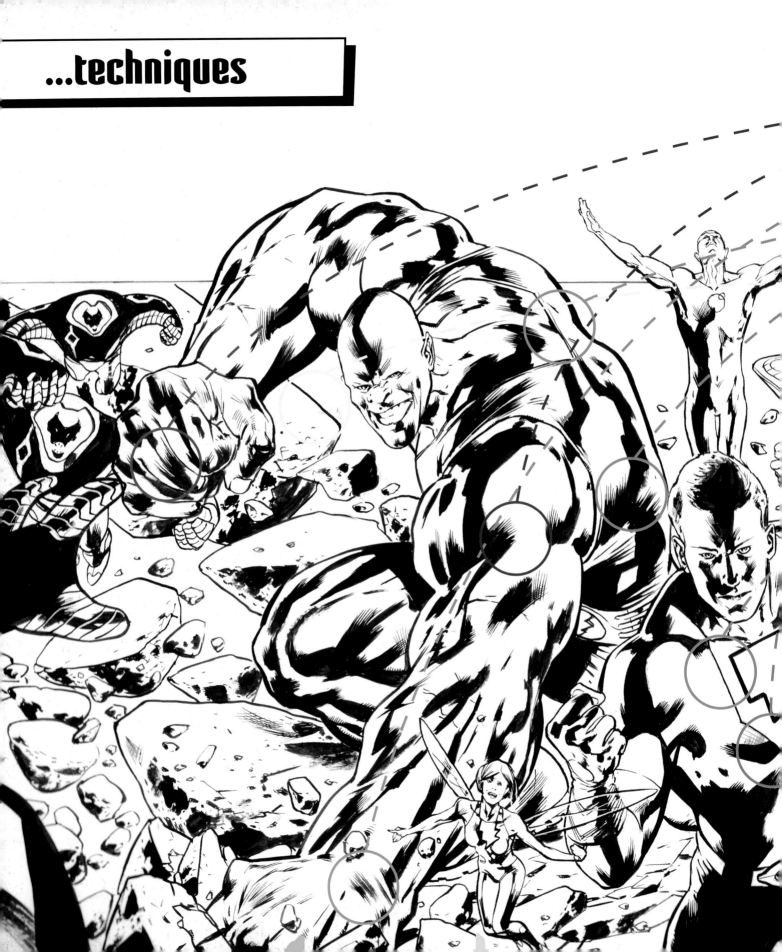

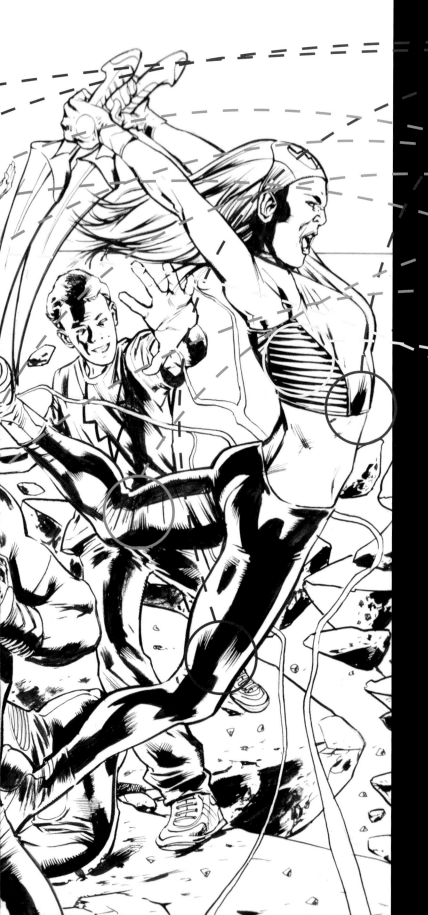

Feathering
Probably the mark that you will use the most often. Brilliant for detail, tone, adding form and showing curvatures in body outlines.

Hatching
Diverse free-hand mark that you will use a lot. Cross-hatching provides the greyer shades.

Pen rule
It's not just the obvious object outlines that require ruled lines – they come in handy for many areas. Remember, use pens when you want a hard line.

Brush rule
The brush rules are softer and more organic. You can vary the weight, which you can't with a pen rule, and can achieve a long line with varying thickness and tapering along it.

Colour – tools and materials

Colouring is the third and final stage in the process of creating comic art. The drawing is finished, the inks have added an interpretation and the colouring is the icing on the cake. I tend to work closely with my colourists to get the images looking just as I want them.

Don't be specific

Just as I can't prescribe to the inker exactly how I want them to ink my work, I can't prescribe to the colourist either. You have to trust them to honour your work and the feel that you're looking for. Thanks to the digital revolution, colour work can now be more of the two-way street, with jpegs flying about the ether between the colourist and myself, with tweaks here and there being requested. It's much easier to work collaboratively, but even with this collaboration I don't tell the colourist what colour to put where.

Hard- and software

A computer is obviously going to be essential for colour work in this day and age. Get a decent one with enough memory to be able to hold and store your artwork, both after you've scanned and sent the inks to the colourist, and for your archive of finished work. A stand-alone hard drive is the best way to store your archive, and is safer should your computer lose the will to live as you will instantly have a back up of all your work.

A scanner is a prerequisite whether you are inking and colouring your own work or sending it out. Inking is the final stage at which you are working on the hard copy, and you need to be able to scan the inks in for colouring. Similarly, there will come a point when you will need to email examples of your work to people, so having the capability to take your work onto your computer is essential.

There are several colouring programmes available, but by far the most common is Photoshop, and you will find that this is what everyone uses. There are tutorials available online and loads of books to help with the physical colouring tools and techniques, which are beyond the realm of us here!

Image size

If you are working on a professional commission then you will generally have had the required image size specified to you. Marvel comics have a standard format which the images have to match, and the resolution will also have been specified. As a rule of thumb, for print-quality images you need to aim between 300 and 400dpi (dots per inch) resolution. Whatever size you choose, make sure that your image isn't the size of a house and too big for your computer – and the recipient's – to cope with! Both the physical size, the file size and the resolution can be changed in Photoshop.

These days a computer is essential for colour work, so make sure that your computer has a good clear screen that shows your colours accurately.

Artwork for Soon I will be Invincible. *The character is Dr Doom-esque.*

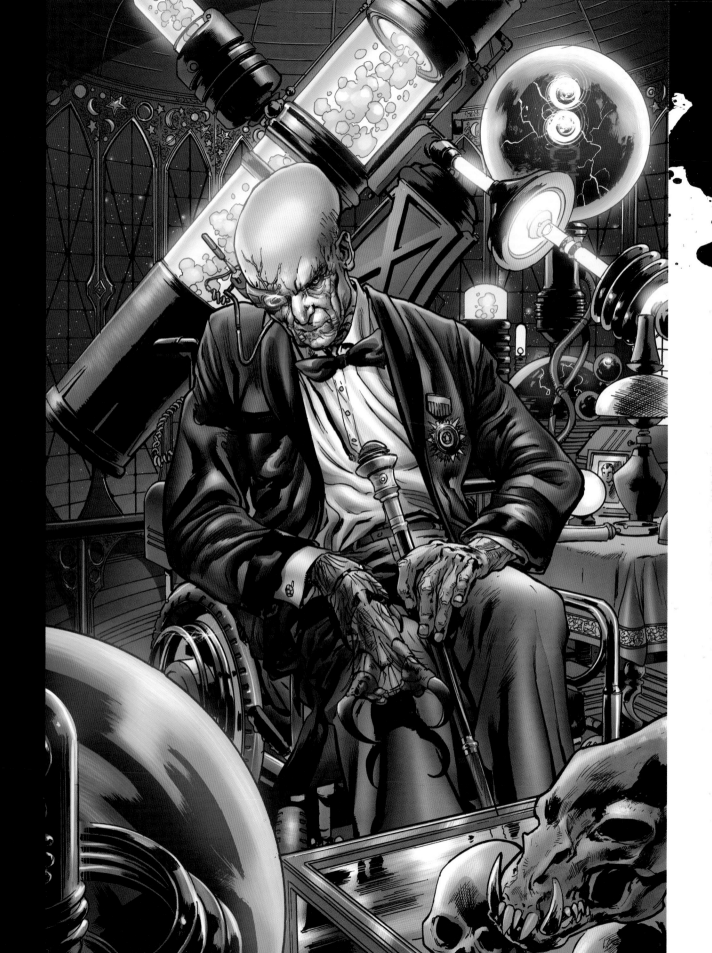

Colour approaches

Despite not being given a prescription by the artist, the colourist has a pretty good idea of the general colour scheme that they're going to use as a result of where the story is in each panel. As with anything in comic art, the colour has to accentuate and better tell the story.

Colour palettes

When colouring panels you, or the colourist, need to ask the same questions that the artist does at the very beginning of the process. Where are we? What is happening? Who is in the story? When is it? These are all factors that determine the colours that need to be used.

Temperature

The colour temperature of a panel and page is an important part of the storytelling process. The light on a snowy, overcast day in the city is going to be predominantly cold – grey, compared to the blue of a snowy scene on a clear day, or at night. Hospitals lend themselves to a cool green colour scheme, while deep inside the control room of a spaceship screams hot red.

Characters' costumes are another element of colour on the page. Remember that these need to be recognizable as 'uniform' or everyday clothes, or alternatively that they're iconic clothing, such as a doctor's uniform, or an army suit. These have pre-determined colours that need to work with the environment. These are all the considerations that need to be made when colouring the pages, and which all add to the reader's experience and belief in the story being told.

Hot or cold

Consider the colour as a storytelling tool, and ask yourself how different your experience of these would be if there were coloured differently, but still trying to tell you the same thing. The colour temperature of the story point is generally the only information that is given to the colourist.

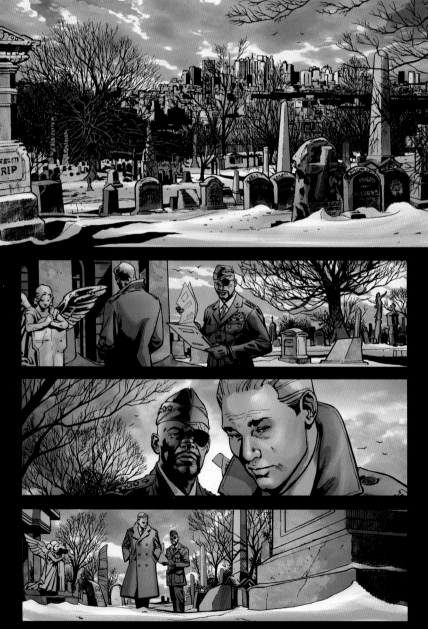

The light in the city on a snowy, overcast day is going to be mainly grey.

A hot red colour scheme is vital deep inside the control room of a spaceship.

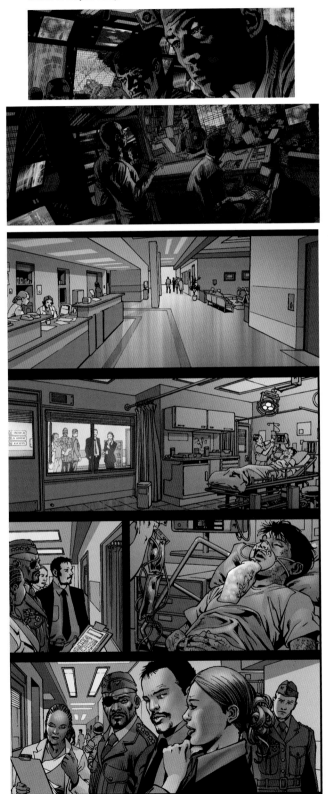

Hospitals lend themselves to a cool green colour scheme.

A snowy scene on a clear day, or at night will be blue.

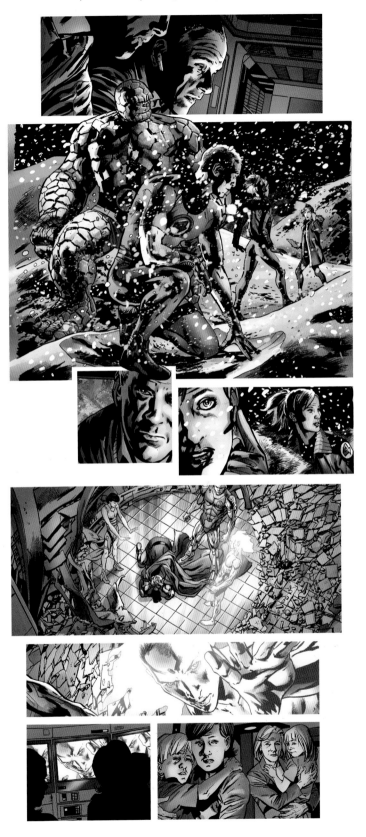

TEETH LIKE FLINT

BRYAN HITCH : ZONK : SLIMER.
STORY/ART LETTERS EDITS

HE IS DESTRO.

UNDER VARIOUS NAMES HE SUPPLIES ARMS TO ALMOST **ALL** THE WORLDS TERRORISTS.

STRONG, POWERFULL AND COMPLETELY RUTHLESS, HE BELIEVES HE CAN ACCOMPLISH **ANYTHING**.

INCLUDING DOMINATION AND **CONTROL** OF THE **COBRA** TERRORIST ORGANISATION!

The business end

I hope that wasn't too disappointing.
I hope you didn't start this book looking
for a step-by-step guide on how to
draw comics. As I said before, I can't tell
YOU how to do it but I have hopefully
been able to offer a few insights into my
own processes. I've spent over twenty
years learning them and still consider
myself a beginner. At best this is an
introduction to the whole thing, a light
dusting of inside information that may
spark an idea or two.

Truthfully, every chapter here could
be a book in itself, but the real secret
here is that, writer or artist, you learn
by DOING. So if you want to draw, DO IT
– draw as much and as often as you
can. Draw anything and everything
and try to learn something from it each
time you do.

Now, let's say you've got the skills.
What next? How do you go about
getting that first commission to
draw a comic?

Sample pages that got me my first commission with Marvel UK. The style is reminiscent of what was fashionable at the time.

Working

As luck and talent would have it, you have showed your work and made an impression. You have received your first professional commission. Congratulations! You are no longer just a fan; you are a pro. This is actually an important realization as it means it's no longer a game, a hobby or something you play at. You are working.

Office hours

The comic industry is driven by deadlines, and you will have to be adaptable to be able to cope with them and get the material delivered on time. With Reborn (right) this meant starting work at the crack of dawn just to get enough hours out of the day.

Discipline

Working for yourself is hard. You may have been given a script, but that makes those people your clients, rather than your employers. They don't do your taxes and they don't organize your time for you. YOU have to do that. The sheer number of late books (and I have contributed to my fair share of those) is testimony to how hard that can be. You do

have to treat it as a job, no matter how much fun it might be. You need to keep a regular working schedule and work out your days to ensure that you can deliver your work when your client needs you to.

Routine

It helps to keep a regular routine – that's certainly when I have had my most productive

periods. Whilst drawing *Authority*, I would get to the desk by 9:30am and finish the backgrounds on the page from yesterday to warm up. When that was done I would sketch out the next page and have lunch. I would then drive over the page I'd finished that morning to Paul Neary (the colourist) share some wine and then run some errands. After dinner I would then draw the figures up on the page

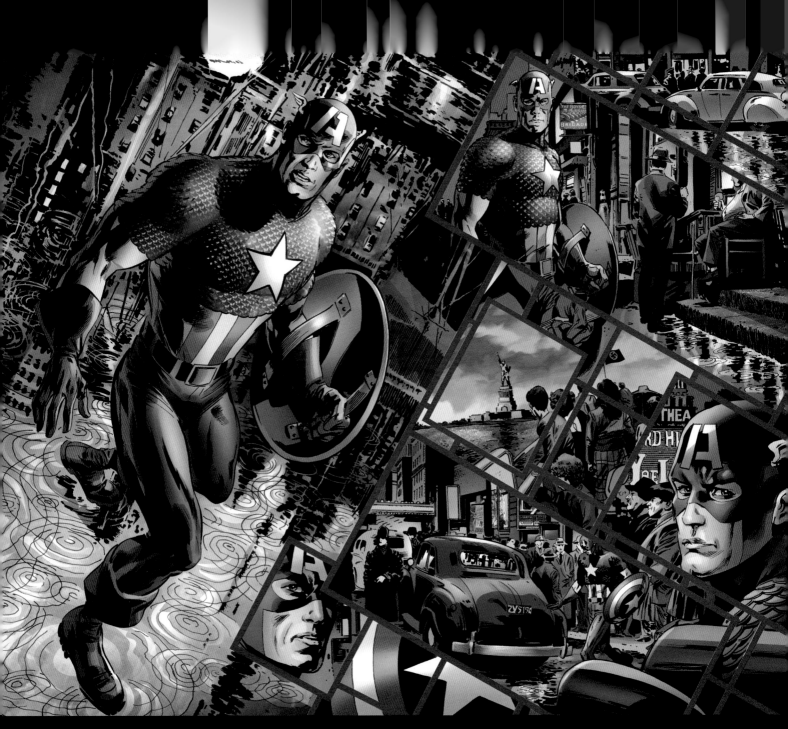

I'd laid out before lunch. This way, Paul and I turned around each issue of the *Authority* in three weeks, and it never felt like it was a chore. There were certainly days that I didn't WANT to draw, where I just wanted to sit in the garden under the oak tree and read or just play the piano, but that is where the discipline is important. If it is a work day and the pages need drawing, then you just HAVE to do it.

Feel the pressure

Whilst drawing *Reborn*, inker Butch Guice and I were under brutal deadline pressure. I found the only way to get stuff done and couriered out to him was to get into the offic e at 4am every morning and work until noon, getting pages packaged each day and shipped by 2pm. Chores and the next day's preparation followed, and home by 4pm.

With each project it was routine and discipline more than anything else that got those jobs done. Save the DVDs, games, online activities and all other distractions until after the work is done. Believe me, there's nothing like the high you get by actually achieving your goals – and nothing like the lows you get, knowing every day you didn't quite make it!

The portfolio

The first thing you need to do is get your work seen and that means a portfolio. When I was starting out a portfolio was a big black case with your artwork (or copies of it) slipped between sleeves of protective plastic. A convention table positively groaned when one was heaved under an editor or an artist's nose for review.

Digital everything

These days it's a little easier with far more options available to you. You have MySapce, Facebook, blogs and websites where you can post your portfolio and send a link to anybody you want to to see it. The digital age has opened up new publishing possibilities, and it also opened up the avenues a budding professional has to flog their wares.

Five pages

So what IS a portfolio? Since we are dealing with comic books here, let's focus on what you would need to show a potential publisher that you could draw comics for their company: five pages. Within those five pages you should have plenty of room to show you can draw people both in action and at rest; in real and imagined environments, wide shots and close-ups and a good grasp of composition within a storytelling framework. See? No pressure. If you go back and look at the three pages I drew a little earlier, featuring 'THE BATTLING BOLTS on page 124 (yes, I am very sorry for the corny title there) you will see that it starts off with a strong establishing shot of a real world environment (New York, where almost all Marvel comics take place) and cuts to a

Showcase yourself

Your portfolio must show the range of skill that the publisher is going to be looking for. Think about the prerequisites of the comics they publish and make sure you get that in – establishing shots, action, fantasy and SF, as well as the more ordinary, everyday shots without superheroes. This is your chance to showcase your talent.

family having dinner together. The whole first page is just real place, normal folks doing everyday things. Then it shifts to an action/ fantasy theme; still within the same setting as the Ver-Men arrive. Our 'normal' people shift to super-hero action mode to fight the fantasy/barbarian themed nastiness. Then a more SF based menace arrives, the Space Skulls and so further action, this time with the kids and then finally the old guy becomes super-muscled and joins the fight. I think three pages like this show a wide enough range that any editor could see you were capable of moving to the next step. These three pages

could also easily expand to five to show further range with escalating scale: outside, a huge space ship appears above Manhattan and a 150 foott-tall alien robot hits the streets and so on.

Or even just three

Really, whether three or five pages, the point is that you can demonstrate an ability to cover the range of visual material a publisher would need from you. Don't show anybody five pages of pin-ups. Comics are solely a storytelling medium, so that is what you primarily need to show you can do.

Superheroes are (usually) people so you need to show that you can draw people. As well as their adventures, the heroes lead normal lives doing ordinary things like teaching, parenting, reporting and so on. Show you can handle it. Then there is the imagination and action that lifts you from the natural figure work and ordinary, every-day environments to other planets, places, times, dimensions and so on. Show you can do all of this, then you will be leaped upon by any and all publishers, offered real money and set to work doing what you love.

It really is that easy…

A foot in the door

So you have your portfolio, your online gallery or an iPad with images loaded and ready to go. Now you have to get it looked at so you can be hired.

You can send your work, in digital or hardcopy form, to the various publishers or their representatives; you could have an agent represent you or you can do what most people do and go to comic conventions and show your work in person.

Try to think of it as an ad hoc job interview and act accordingly. Make a good impression – and not just with your drawings.

Etiquette

Please don't assume that all the editors, publishers or artists are waiting to see you and are delighted to do so. They aren't, but under the right lighting conditions they are probably willing or happy to give you a few minutes and a review of what you have. Be warned: you will hear things you don't want to. If you are showing your work, you must be already thinking you are ready to be a professional, just like all the artists whose work you have admired and emulated. In 99% of the cases, this is a delusion, I'm sorry to say but there is that 1% that all the publishers are looking for and it MIGHT just be you!

Be polite. Don't interrupt the person you are waiting to see if they are talking to somebody else. Don't hover and fidget – come back later if they are busy. First impressions count and you want them to be happy to view your work, not heave a sigh at the end of a long day and be cross when doing so. The outcome then will never be good. NEVER approach said publishers, editors or artists when they are outside of the convention environment in the bar, hotel, eating dinner or other such activities.

Show the working out

If you are going to show an example of your work it is also a good idea to make sure you have copies of the pencils, inks and colour so that you can show the different stages.

Respect

None of us want to tell you that your work isn't ready yet and if we are offering you advice on how you could make it ready, LISTEN. We aren't trying to trip you up and we aren't afraid of the competition. What we ARE trying to do when we offer comment is give you the benefit of the knowledge we have all gained by being professionals in the industry you long to join. If we do criticize your work, don't try and excuse it by explaining why it's the way it is. It must speak for itself and if what it says is that you aren't ready, no amount of reasoning or explanation as to why you did what you did will change it. Only better work next time will do that.

If you are at the convention to network and to show off your work, behave. Please don't get drunk, high or trashed and leave an unpleasant memory with those you should be aiming to impress. Honestly, we pros behave badly enough at the best of times but if you want to impress, treat your whole time in the company of editors or creators like a job interview, no matter where your paths cross.

Where to go

I'd recommend going to the smaller shows rather than the behemoths like San Diego Comicon. It's an incredible show and an amazing experience but it's also such a big media event that a new artist is going to get lost in the scuffle. At the smaller shows, we are all going to have much more time to talk and look at what you have to offer and more time to be impressed.

Showing your work at a convention is like compiling your portfolio, so the same rules about demonstrating the breadth of your technique, talent and subjects apply.

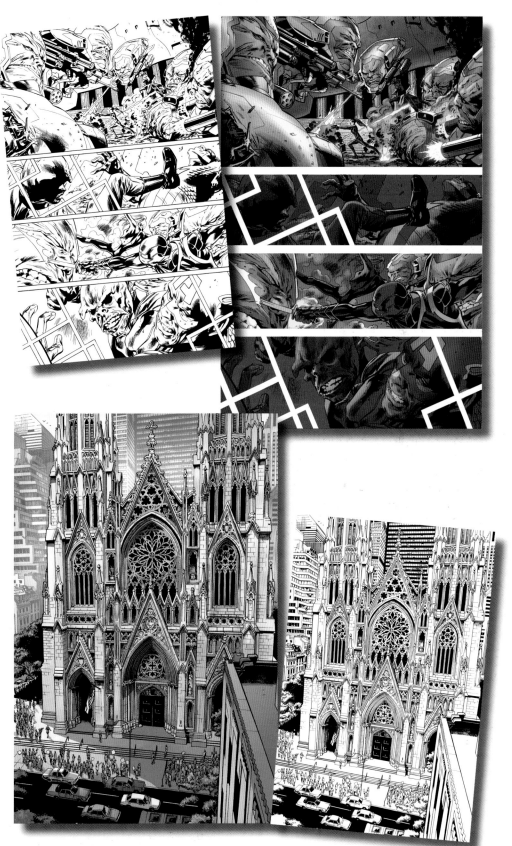

The future

Twenty years ago I was told by a long standing professional that comics were doomed. five or ten years and they would be gone. None of us know what's coming of course but we can say with a degree of confidence that comics aren't dead. They aren't even dying.

Since that pro predicted the industry's demise, we have seen its greatest peak and its greatest trough. Pretty much every book you see out there is making a profit. If it wasn't it wouldn't be published, for long anyway. Comics may not be dying but they are changing. They are no longer disposable newsprint periodicals but high quality and expensive productions. The demise of the newsstand market hit hard and has made it difficult to find the monthly comics, as they are only available in specialist outlets. Hobby stores, really. A collectors market, then, rather than a mass-market.

Now, the books are collected and have a much longer shelf life in bookstores and that has led to a change in the way the stories are conceived. The Apple iPad has launched and with it the Marvel App to allow you to download and read your comics in digital form – and they look amazing. I think the point that may have escaped that doom-speaking pro is that there seems to be a continuous interest in the material published in comics. The delivery systems may change but as long as you are telling stories people are interested in reading and enjoying, the industry and the medium is kept alive.

Superman is just short of his 75th birthday and Captain America is nearly 70. Honestly, we're just getting started.

The cover

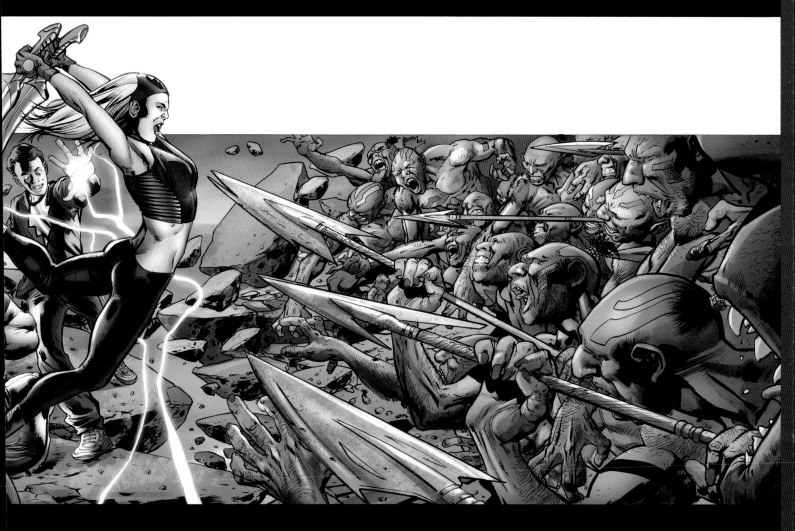

Cover story

Creating the cover for this book was a real challenge. This is a personal project and, as such, didn't have any pre-conceived characters or storylines. I just had to come up with a new piece of art. Simple, right?

Unrecognizable

Not only did the characters have no backstory, they also had to not resemble the characters that I have been drawing for the past ten years of my work. Now it's sounding tougher, isn't it? It's like when someone finds out that you speak a foreign language and says 'go on, say something in that language' and your mind goes blank and you just can't think of anything. If they were to say 'tell me where the bank is' you'd be able to do it without thinking.

The brief

So the brief was simply nothing copyrighted or licensed, but had to be 'iconically Hitch'. I don't appraise my own work very often. I will sometimes come across a piece that I did years ago and think 'wow, I really like that', or 'what on earth was I thinking', but I certainly didn't know what a piece of art that was 'iconically me' looked like. I have spent years drawing other people's characters that everyone's already familiar with, and I just couldn't see how anyone would be interested in me drawing a bunch of characters that no one knew. I kept telling my publisher that I couldn't do it, and could I just draw my head exploding instead as that was much simpler? I just couldn't get beyond the idea that I could have, and was actually required to have, an idea all of my own.

Since these characters had no backstory I had to make something from scratch. I began sketching out possible suerhero forms and costumes to provide the core dynamic figure for the cover arrangement.

Lightbulb

An idea came to me, as it always does, out of nowhere. I genuinely don't know what the inspiration was, I just knew that I had to have a central image for the front cover of all the editions, and some of the other editions were going to have gate folds requiring even more of the image. So the concept I came up with had to cover those practicalities. The creation of a generic superteam seemed like the ideal solution to cover all of those bases. And of course a superteam has to be under attack to reveal just how super they are, so I chose to have a barbarian army on one side, and a futuristic, sci-fi character on the other. This idea seemed to cover all bases – we had the superhero, we had the fantasy element, and we had the grungy barbarian early stuff. I'm still not sure if it's 'iconically Hitch' though, as I'm still not really sure what that is.

I worked up a number of different scenarios until I settled on the idea of the superhero gang. I'm known for drawing groups, so this seemed to fit with the brief. To get to know a character properly I find it's an important part of the process to work out what they're like when they're not in superhero mode.

Each sketch took a few minutes each, and enabled me to work out who these characters might be. Male or female? A team? With whatever I'm drawing I just put my pencil to paper and start working it up until it starts to take form – it's a way of visually humming to yourself until a tune happens.

Next steps

I developed the idea of the story once I had settled on the idea of the team. This enabled us to the do the group dynamic of naturalistic figures as well as the science fiction element.

Having developed the characters I moved onto my basic thumbnails for panel shapes, rhythm and flow. The composition for each panel then grows, and you can see that the initial ideas have remained through to the final panels.

You are here

You know with any story sequence that you're going to have an establishing shot, and you have to decide when that's going to fall, and how many you're going to do. In this case I chose to have an exterior establishing shot, followed by an interior one of the restaurant. You could also choose to start with a close-up, and then pull back to an establishing shot, which is a bit more subtle than simply saying 'you are here'.

These scribbles don't mean anything to anyone but me, but they are a way of working out the panel composition, order, camera angles and flow of the story. This means that when I come to pencil the final panels I know that any compositional problems have already been ironed out.

Even though these thumbnails are incredibly rough you can still see the logical progression from this first articulation of the idea to the finished story.

A scene where everyone is sitting around a table, such as in a restaurant or meeting room, is a good way of introducing a large number of people.

I had to rough out the order of people around the table, and decide who would have their back to the camera and exactly where everyone was going to be in the shot.

I needed to make the father the significant figure in the scene, otherwise with everyone else sitting down it would be hard to find the focus. I decided to have him standing and raising a toast, and having the camera angled from his point of view meant that we could see beyond him to everyone else. Having him at a different level meant that there was sufficient space under his oustretched arm for a speech bubble, which is always a challenge in a shot with multiple characters.

The story itself came about as I was thinking about the cover, but it was physically written after I had finished the cover. It was always in my head, however, just as any script is when I'm drawing.

My thought process as I was drawing the cover led me from a group of superheroes to a family, all the while thinking about the characters, their personality and where they were going to go.

With a powerful action shot you need to make sure that the reader sees the impact at the end, rather than the impact before the blow that delivered it. Here, that meant that the impact had to fall at the bottom right of the panel, which is the last bit you see as you read left–right, and I could get all that power into the punch and the impact without any of those dreaded speed lines.

I hit on the idea of having the grandparents in the family, and really liked the idea that the grandmother had no superheroic powers, but the elderly grandfather turned into this age-less Hulk-like creature.

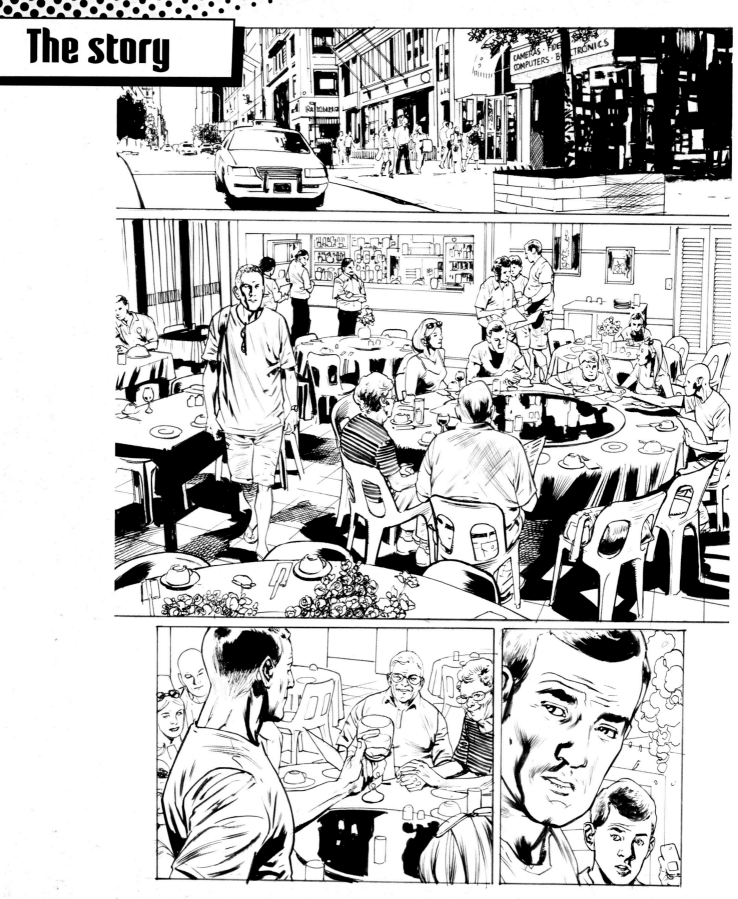

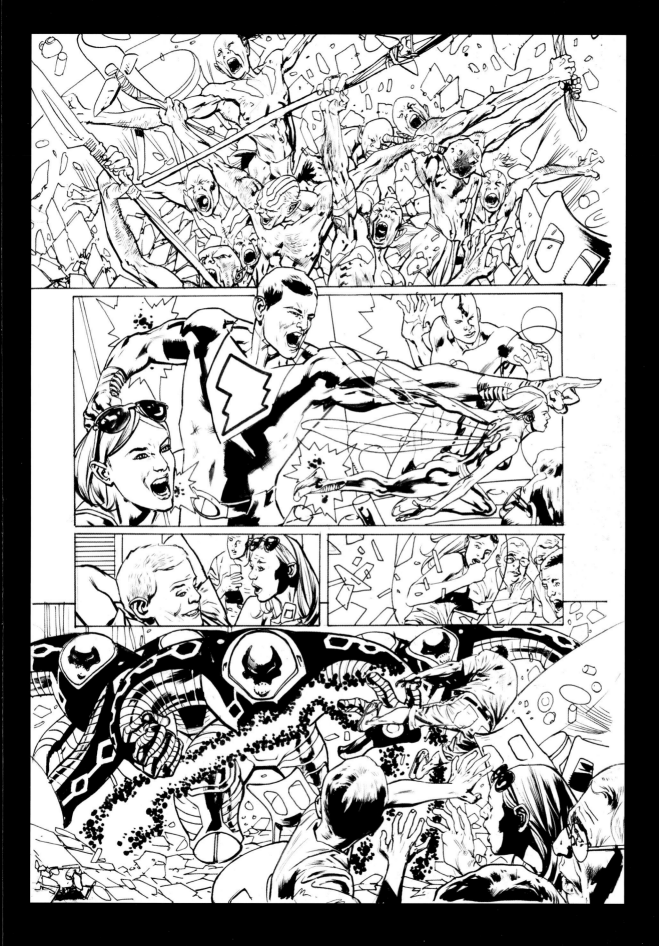

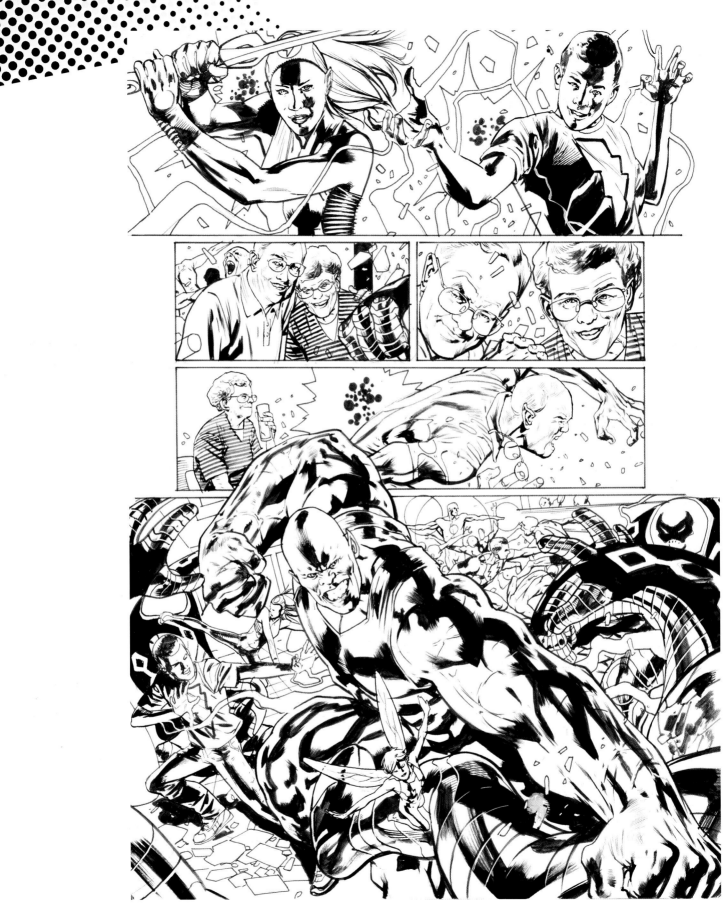

Acknowledgments

A project like this needs a lot of hearty handshakes and back patting.

Firstly to Dan Buckley and his staff at Marvel Comics. Without Dan's help and encouragement, not to mention generosity in arranging such a wide range of image use, this book would never have got started. A true gent.

Huge thanks must go to Freya at D&C for kicking me to get it done and proposing the whole loony thing in the first place. Constantly enthusiastic and encouraging she is doubtless the engine of the whole deal.

Our esteemed Editor, Emily Pitcher who, it needs to be said, really did all the work. The bulk of the text, beyond a few areas was all taken from question and answer sessions, emails, phone calls and lunches. It was Emily that turned it into a book. Plus we swapped recipes and that made it all worthwhile…

Andrew Currie, Paul Neary and Butch Guice inked most of the art here and Paul Mounts Coloured it. They are beyond the best. Laura Martin coloured what Paul didn't, including the eight-page spread from Ultimates 2. Just shows, they are all as mad as me.

Mark Millar and Ed Brubaker wrote most of the stuff I've drawn here and they deserve thanks for giving me such great stories to tell.
I'm going to thank my family now. My wife Jo, and my five boys; Josh, Ollie, Will, Ted and Bertie. If anybody has to put up with me when I'm doing all this crazy stuff, they do, especially during the madness of Ultimates. I love them for making my life even crazier than I could manage on my own and being there to enjoy the ride with me. If I do this stuff for anyone, I do it for them.

Picture credits

Unless otherwise indicated hereinbelow, or with a credit adjacent to a particular image, all comic book art in this book is Copyright 2010 Marvel Entertainment, Inc. and its subsidiaries and is used with permission.

pp. 18–19, 34b, 36b, 38, 41t, 60–69, 72–75, 80t, 81t, 100–101, 106, 112, 116–127 © Bryan Hitch

Images and character designs on pp. 25t, 40, 96t, 103 © Bryan Hitch

The stories, likenesses, designs and artwork above were the creation of Bryan Hitch who maintains sole ownership and copyright.

pp. 12, 50–59, 92, 94–95, 96r, 98–99, 102, 108, 114–115 © David & Charles

pp. 42t, 43l, 44r, 45t+m, 83t © Getty Images

p. 88br © istockphoto

Index

action: camera angle impact 35, 88; focal point 36, 49, 72; portraying 19, 63–65, 72, 74–77; sequential 20–21; widescreen shots 25
Action Force 9, 10
Authority 108
The Avengers 76

Battling Bolts 18–19, 110–11
black shapes 40–41, 42, 96
Black Wolf 40
brushes 94, 98, 101
buildings 40, 41, 43, 80–81

camera placement: case study 88–91; character movement 74–75, 88–91; composition 34–35, 56; portraits 25; storytelling 17, 19, 20, 21, 26
Captain America 14, 43, 48–49, 70, 85, 114
characters: placement 37, 38–39; sense of reality 46–47, 62, 64; storytelling 16, 20–21; visualisation 18, 54, 83; *see also* figures
colour 42–43, 102–5
comics 8, 93, 114–15
commissions 95, 107–13
composition: camera placement 34–35, 56, 88; *Captain America* case study 48–49; character placement 38–39; creating roughs 32–33, 55; environment 42–45; finding focus 36–37, 49, 72; graphic blacks 40–41, 42; panels 17; problem-solving 10, 18, 34, 38, 48, 54, 56, 120; verisimilitude 43, 46–47
computer 12, 53, 102, 110, 112; software 12, 40, 53, 102
conventions, attending 112–13
costume 69, 78–79, 104
cover 116–26

detail 25, 79, 96, 99
digital format 110, 112, 114
Doctor Impossible 25
Dr Doom 30–31
Dr Who 10
drawing: case study 88–91; costumes 69, 78–79; environment 80–83; figures 62–69; hands and faces 70–73, 77; hardware 84–87; portraying movement 74–77; process

51, 54–57, 107, 120–23; tools and materials 32, 52–53; using imagination 82–83, 118–19

emotions 17, 51, 70, 77
Empire publication 11
environment: composition 40–41, 42–45; portraying 24, 26, 28, 51, 54, 80–83, 87
erasers 59
eye movement 31, 36–37, 49

facial expressions 17, 25, 51, 70–73
Fantastic Four 17, 26–29, 30–31, 39, 44–47, 71, 88–91, 97
feathering 98, 101
figures: drawing 10, 51, 62–69; hands and faces 70–73, 77; portraying movement 74–77
foreshortening 35, 72, 74–75, 77

hands 70–73, 77
hardware 84–87
hatching/cross hatching 98, 101
The Hulk 77

inking 92–101, 102

lightbox 33, 41, 56–57, 68
lighting: figures 64, 67, 69, 76–77, 79; storytelling 17, 42, 51
location 24, 26, 28, 42, 80–83, 87

mark making 58–61
Marvel UK 9, 11, 80, 83, 102, 106, 114, 127
mood 17, 42, 51, 70, 77
movies 8, 10, 17, 19, 20

negative drawing 41
New York 24, 43, 45, 46, 80–81, 83, 87
night shots 40, 41, 42, 83, 105

pace, changing 21, 22–23, 26, 28
panels: composition 17, 29, 59; focus 36–37; frames 55, 56; size 22–23, 25, 29, 55; storytelling sequences 16–17, 20, 21
pencils 32, 53, 56, 58–61
pens 93–95, 96, 98–99

perspective 34, 35, 36–37, 48, 72, 74–75
portfolio 95, 110–11, 112
portraits, close-up 24, 25, 35, 70
publishers, approaching 111, 112–13

Reborn 109
reference shots 31, 43, 64, 66, 75, 79–81, 85
roughs, creating 32–33, 55
ruling lines 98, 101

scale 25, 40
scanner, flatbed 12, 53, 102
script 16, 18, 20, 32, 54, 81
SFX 10, 41
shading/tone 53, 58, 61
silhouettes 40, 41, 42
Soon I Will Be Invincible 9, 24–25, 102
speech bubbles 21, 36, 38–39
Spiderman 83
storytelling: case studies 26–29, 117–26; colour 104; hands and faces 72–73, 77; process 10, 16–17, 120–23; rhythm 22–23, 27, 29; sense of reality 46; sequential action 20–21; trademarks 24–25; visualisation 18–19, 43, 83
style, personal 24–25, 96, 97, 99
supports 94

The Thing 35, 91
tools and materials 12, 52–53, 59, 94–95
trademarks 24–25
Transformers 10

The Ultimates 6, 20, 24, 25, 79, 82, 85, 87

vanishing points 34–37, 48, 55–56, 74–75
verisimilitude 43, 46–47, 62, 64
viewpoint *see* camera placement
visualisation 18–19, 54, 83

weapons 84–86
widescreen shots 25
working as artist 95, 107–13
workspace 12–13, 59, 94